Carving Noah's Ark

MRS. NOAH & FRIENDS

With the Animals of North America

David Sabol

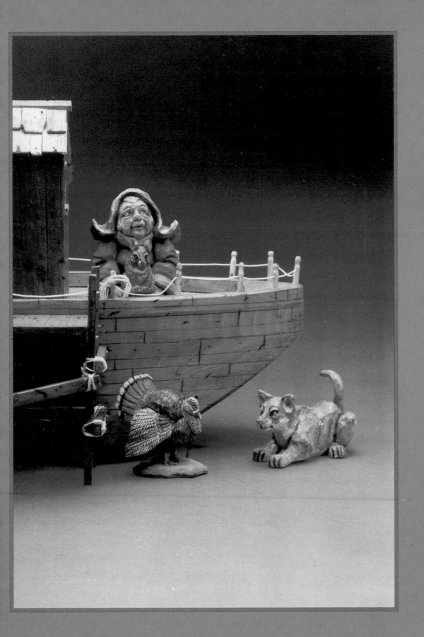

Written with
and photographed by
Jeffrey B. Snyder

Schiffer Publishing Ltd

77 Lower Valley Road, Atglen, PA 19310

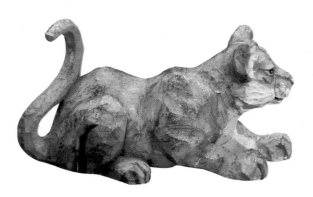

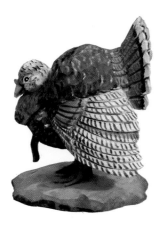

Contents

Copyright © 1995 by David Sabol

Library of Congress Cataloging-in-Publication Data

Sabol, David.
 Carving Noah's Ark : Mrs. Noah & friends, with the
animals of North America /David Sabol; text written
with and photography by Jeffrey B. Snyder
 p. cm. -- (A Schiffer book for wood carvers)
 ISBN 0-88740-731-5 (soft cover)
 1. Wood-carving. 2. Wood-carved figurines. 3 Noah's
ark in art. 4. Animals in art. I. Snyder, Jeffrey B.
II. Title. III. Title : Mrs. Noah & friends. IV. Series.
TT199.7.S212 1995
731'.884--dc20
 94-37322
 CIP

Printed in China
ISBN: 0-88740-731-5

Published by Schiffer Publishing, Ltd.
77 Lower Valley Road
Atglen, PA 19310
Please write for a free catalog.
This book may be purchased from the publisher
Please include $2.95 postage.
Try your bookstore first.

We are interested in hearing from authors
with book ideas on related subjects.

Introduction

Almost everyone is familiar with the story of Noah's ark. In this book, I want to help you begin bringing that story to life. Together we will go through each step necessary to start populating your ark. We will carve Mrs. Noah, a puma and a turkey out of blocks of white pine and paint them with oil stains.

Each step will be clearly described and well photographed to provide straight-forward, confidence-building directions throughout these projects. When we are done, you will have created works with intricate detail and realistic finish.

Each animal project also provides patterns for both the male and the female. Each is set in a different pose and every animal is portrayed in a way that accentuates individual personalities and characteristics. This gives your growing collection more diversity and life.

My tools of choice for these projects are: a band saw (for cutting out each figure's basic shape from it's pine block), a bench knife, gouges (numbers 7, 8, 9, 11, and 15), a #7 fishtail gouge, V tools (numbers 12 and 15), veiners (a small veiner and a #12), and a wood burner. Power tool assistance is never used after the initial blank is cut from the pine block. Oil stains created from oil paints mixed with Minwax Natural, freezer paper, and brushes (a fan brush and numbers 1, 4 and 8) are used to finish each piece. I hope you will enjoy these projects.

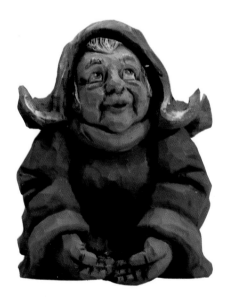

Carving Mrs. Noah

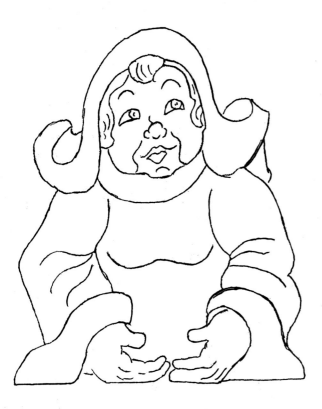

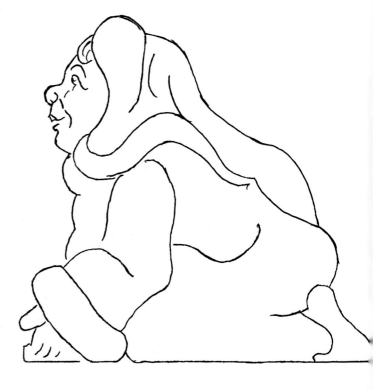

Transfer Mrs. Noah's basic pattern to a 3" wide block of pine and cut the pattern outline from the pine block with a band saw. Then transfer the outline of the front view to the pine blank and round down toward the shape of the head with a #7 gouge. After rounding, begin to carve by removing excess wood from around the face with a bench knife.

First establish a place for the face, drawing in the shawl and a center line for the face. Remember that the face is angled and the centerline for the features must be angled as well. The exposed head inside the shawl is one inch wide. Take the bench knife and cut straight in on the outline of the shawl. Angle out the cut of the shawl and round the area of the face as you go. This will be repeated several times as we want a lot of depth for the face.

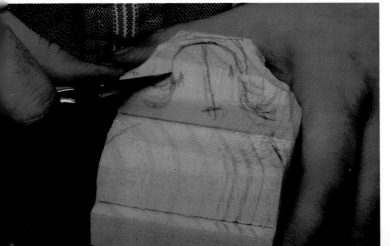

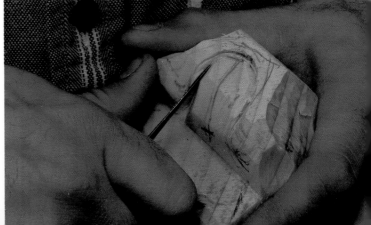

Once the area of the face is well established, draw in the outline of the shawl on the side view in pencil. Make sure not to use straight lines here. Give the shawl curves for motion. Once the shawl is well drawn, recess the shawl with a #7 fishtail gouge so we can see the face.

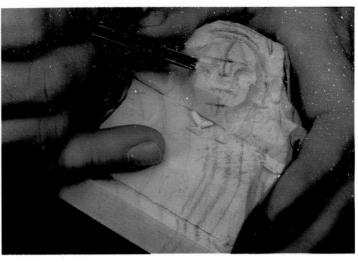

Mrs. Noah will not have a very big nose. Using a #11 gouge, begin removing wood from around the nose.

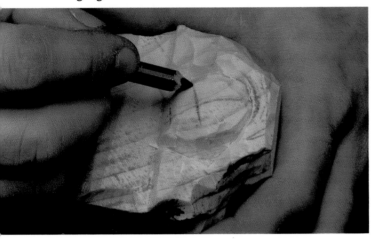

Of all the facial features, the nose sticks out the farthest. Everything else is recessed behind the nose. Therefore we will establish the location of the nose first. Since Mrs. Noah is looking up to the left, all the lines must be angled up left-ward to maintain the proper angle of the head.

Recess the forehead away from the nose with the bench knife, remembering to leave a little mound for the nose, and another for the curl of hair sticking out beneath her shawl, as you go.

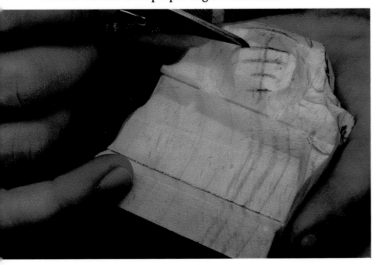

Keep the lines for the eyes, mouth, and chin parallel to the nose and to each other. They must also be 90 degrees off the center line. I am pointing to the guide line for the eyes here.

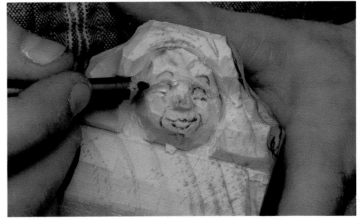

Establish the face now. Round the cheeks a little with the bench knife, keeping in mind that Mrs. Noah will have plump cheeks. Using a pencil, follow your guide line and establish where the eyes will be. To make sure they are properly separated, keep the eyes one eye width apart. Pencil in the rest of the details of the face from the pattern.

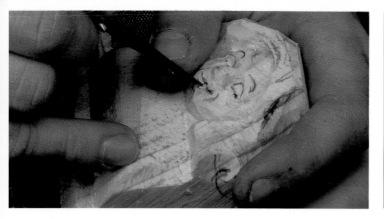

Now we will work on the mouth and the chin. I tend to do the eyes last. To give Mrs. Noah a nice little smile, first make a stop cut along the pencil line of the upper lip with the tip of the bench knife.

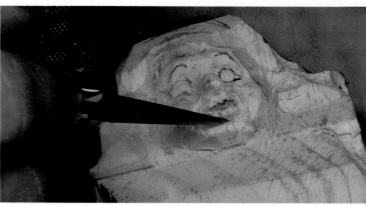

Make little cuts down from the base of the lower lip, recess the chin. Be careful as you cut to leave a full lower lip.

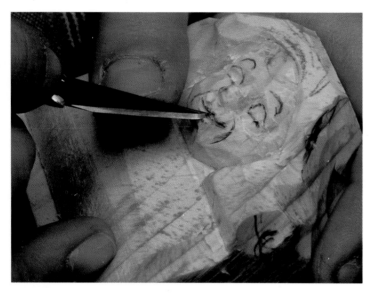

Then cut in at an angle from the bottom lip and meet the stop cut. A small chip will be removed, defining the lips.

Give Mrs. Noah a little hair on the sides of her head. To do this, make two vertical cuts with the bench knife along the pencil lines to create a stop cut. Then recess the side of the face slightly to meet that cut, allowing the hair to stand out from the sides of her head.

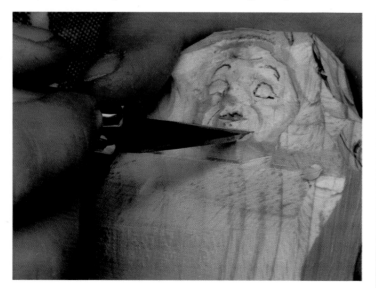

The creases in the face around the mouth accentuate the smile. First make a stop cut along the line of the creases with your bench knife. Then make an angled cut with the bench knife in to the stop cut, blending the creases into the cheeks.

Taking a #11 gouge, define her little button chin. Just follow the creases around the mouth and place two cuts on either side of the chin.

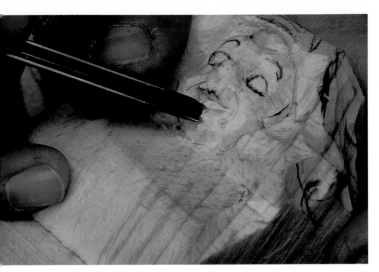

Make a circular undercut of the lower lip with the #11 gouge. This creates a smaller and more rounded mouth. Women have delicate features, the smaller and more rounded they are, the more feminine the face will be.

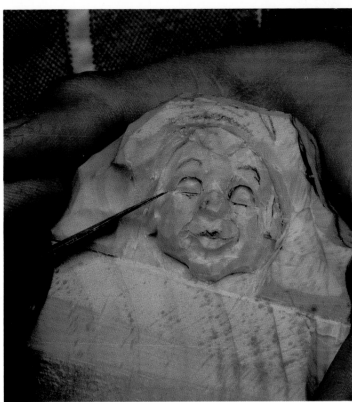

Here are the rounded eyes and the face so far.

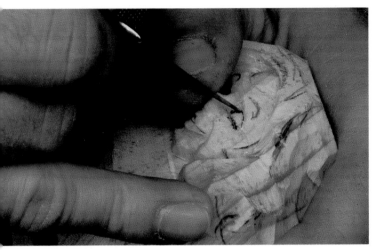

To begin carving the eyes, first cut straight in with the tip of the bench knife along the line of the eyelids. This will create stop cuts.

Now using the tip of the bench knife again, angle in toward the stop cut to round off the eyeball.

Give Mrs. Noah a couple of small wrinkles under the eyes with a small veiner.

7

Round off the upper eyelid a little with the tip of the bench knife to soften her features further.

To give her eyebrows, make two little quarter moon cuts around the eyebrow lines.

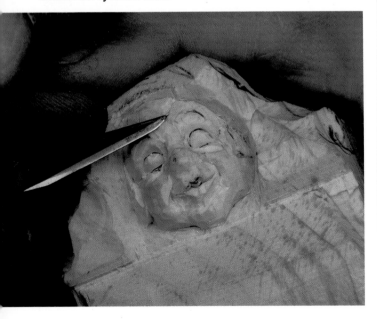

Recess the wood around the cut lines to create delicate raised eyebrows.

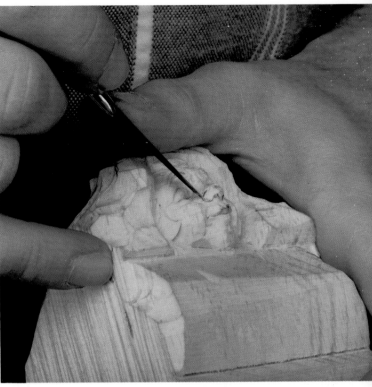

Make small pencil lines for the nostrils and outer edges of the nose. Carve these in with the tip of the bench knife.

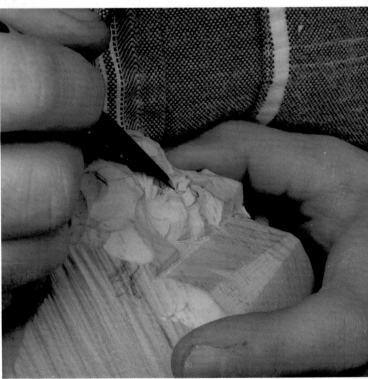

Use the tip of the bench knife to round off the cut line along the back of the nose, giving Mrs. Noah a gently rounded button nose.

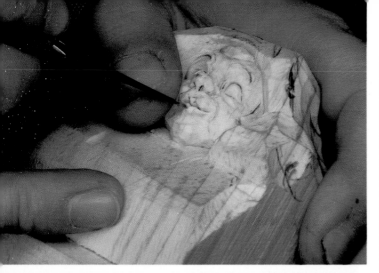

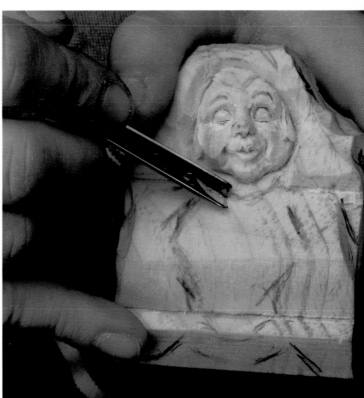

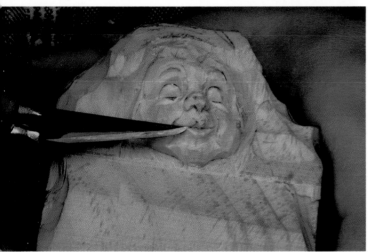

Give her a little undercut into the lower lip where it meets the upper lip to make her mouth look open...like so.

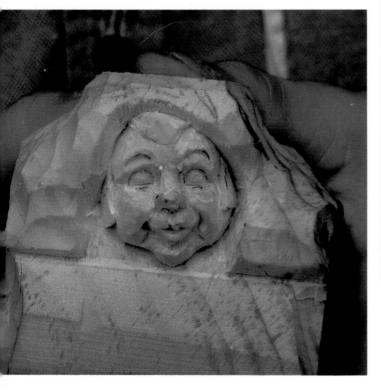

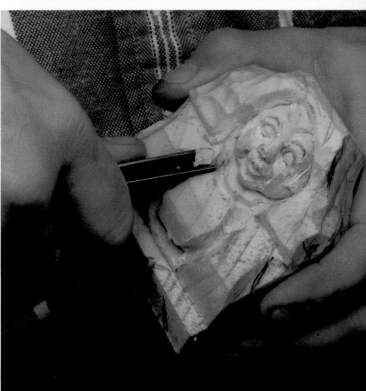

Here we have the pencil marks for the insides of Mrs. Noah's arms. As she is kneeling down, we are going the create the hollow between her arms and also under her collar. Take the #15 V tool and follow the inside of the pencil lines along the arms. Make a separate circular cut to establish the collar.

Except for a little cleaning up, Mrs. Noah's face is done.

9

Using the #7 fishtail gouge, begin to recess the area between her arms to establish a forward lean.

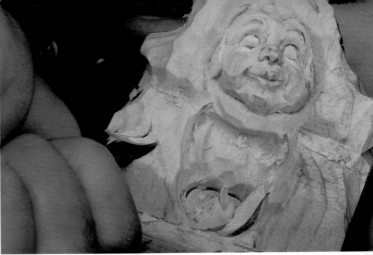

Using the #7 fishtail gouge round off the arms, bringing them back to the shoulders. Remember that Mrs. Noah is wearing long sleeves. Leave enough wood for the folds in those sleeves. Refer to your penciled in side view for the proper location of the shoulders.

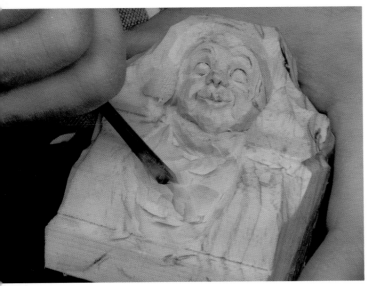

Recess more deeply just above Mrs. Noah's hands. Make sure to leave enough wood for her bosom.

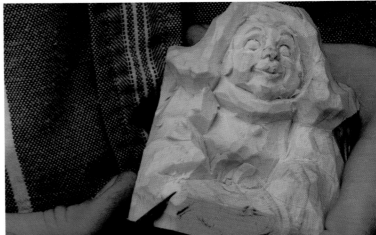

Here are the rounded arms. Note that in rounding the arms we have also begun to define the lower edges of the shawl.

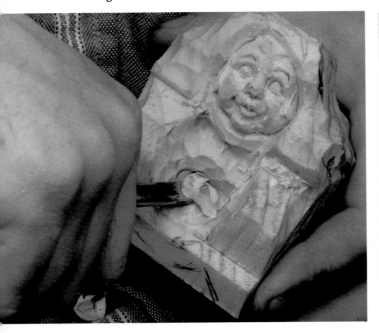

Use the #8 gouge to recess the area above the hands further.

Next we are going to the knees. Seeing as Mrs. Noah has a long flowing gown, we are just going to suggest her knees in it's drapery. Following our pencil lines on the side of the body we take our #15 V tool and make the outline cut.

Define the back of the shawl with the #15 V tool as well.

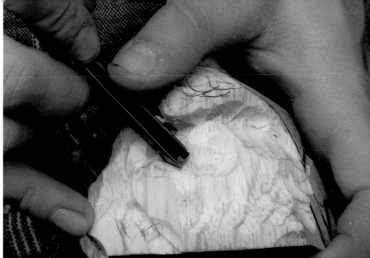

As you round down the body, widen the curved lines made earlier to define the knees by making two V cuts with the #15 V gouge. This will outline the back of the arm, the body, and the legs beneath the robes as well as the knees. The folds in the robes will do most of the work delineating the legs later.

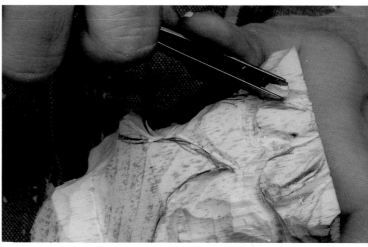

Now we will establish the lines of the bottoms of the shoes. Take the #15 V tool and follow the pencil lines of the feet. This will make it appear that her behind is resting on her heels. This weight displacements will be shown by the folds of the robe following the angles of her shoes. In this crouch the heels fan out for support and the toes and balls of the feet come together.

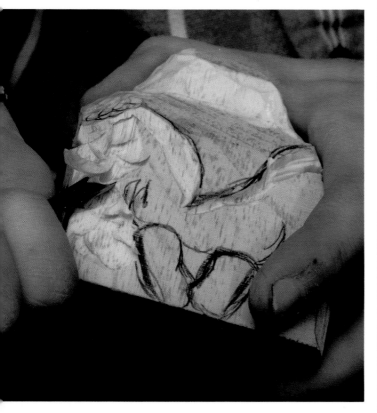

Seeing that Mrs. Noah is a little wider at the knees than behind we will have to narrow her rear. First draw in her feet and behind to insure that you will leave enough wood to carve them later. Then use the #15 gouge to begin recessing her back end.

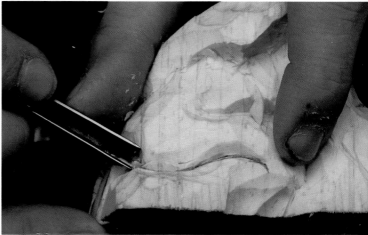

Use the #15 V tool to carve in a curved line suggesting the line of the lower leg as well.

11

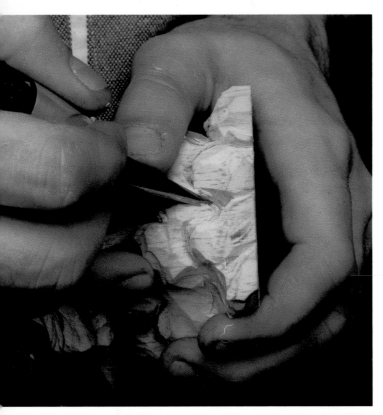

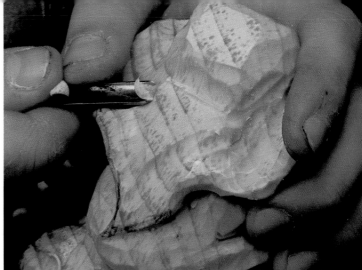

Take the #8 gouge now to carve the shawl, giving it a little life with flowing contours. Where it drapes we will hollow it out and where it rises we will undercut. This is very much a freehand operation but remember where the back and the head are. We want the folds to go up toward the backbone to indicate the line of her back.

Let's give a little form to the feet. Following the original cut with the #15 V tool used to delineate the top of the heels, cut in with the bench knife to further define her shoes. Carve the shoe inward on an angle sloping toward her body.

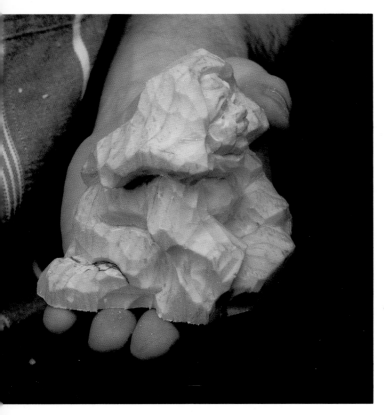

Here is Mrs. Noah as we have carved her so far.

We're going to switch to the small veining tool to create a seam, giving the impression of a little folded over flap in the shawl. Mark the seam line in pencil. Take the #12 veiner and make a small cut along the inside edge of the line.

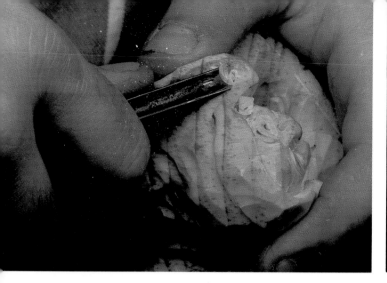

Round down the shawl behind the seam. This #9 gouge is good for getting into the tight spots. It is also useful for putting some folds in the back of the shawl. The bench knife will work well in larger areas.

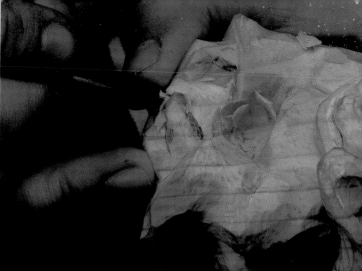

With the bench knife, carve away from around the thumbs and behind them, using the valley we made between the two thumbs to get behind them.

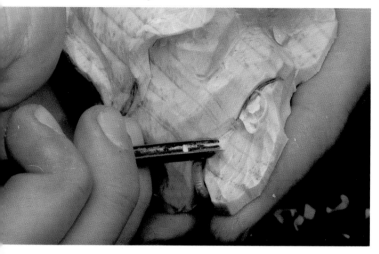

Use the #9 gouge to add folds to the robe as well. Here are the folds in the portion of the robe spread on the ground around Mrs. Noah's feet.

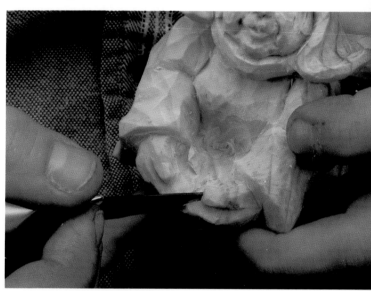

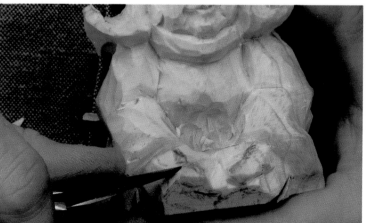

On to the hands. The hands are going to be cupped with the fingers of one hand overlapping the other. The thumbs have been drawn in. We are going to use the small #12 V tool, the bench knife and the #11 gouge. Use the knife to make stop cuts around the thumbs. Since the thumbs are the highest points, recess the wood behind them. This creates a small V between the thumbs which will later become the palms.

Continue reducing the hands. Note the hollow in the cupped hands. You may also overlap the fingers in the front and underneath.

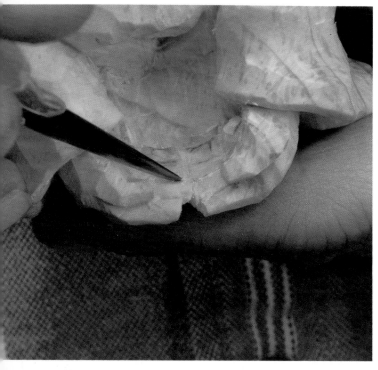

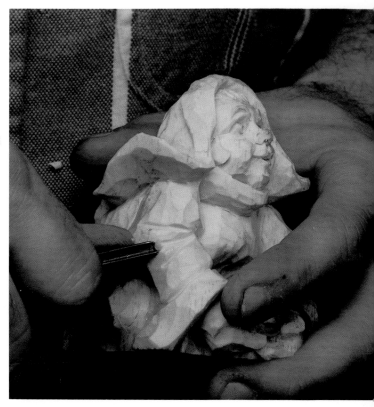

The insides of the palms need some small, slightly wiggly cuts with the bench knife to simulate the fingers and their joints. Repeat the process along the underside of the cup hands, overlapping the fingers if you wish.

Take the #12 V tool and cut some folds in the sleeves at the elbow.

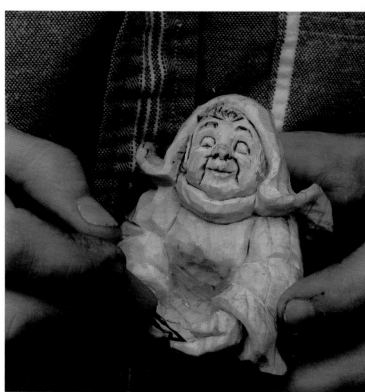

Pencil in some lines for cuffs on the sleeves of Mrs. Noah's robe and carve them in with the #15 V tool. Here you can also see how the fingers overlap underneath.

Take the wood burner and burn in the undercuts of the features and burn in some fine lines to simulate hair and eye brows. The wood burner will also clean up any little fibers of wood sticking up between the fingers.

14

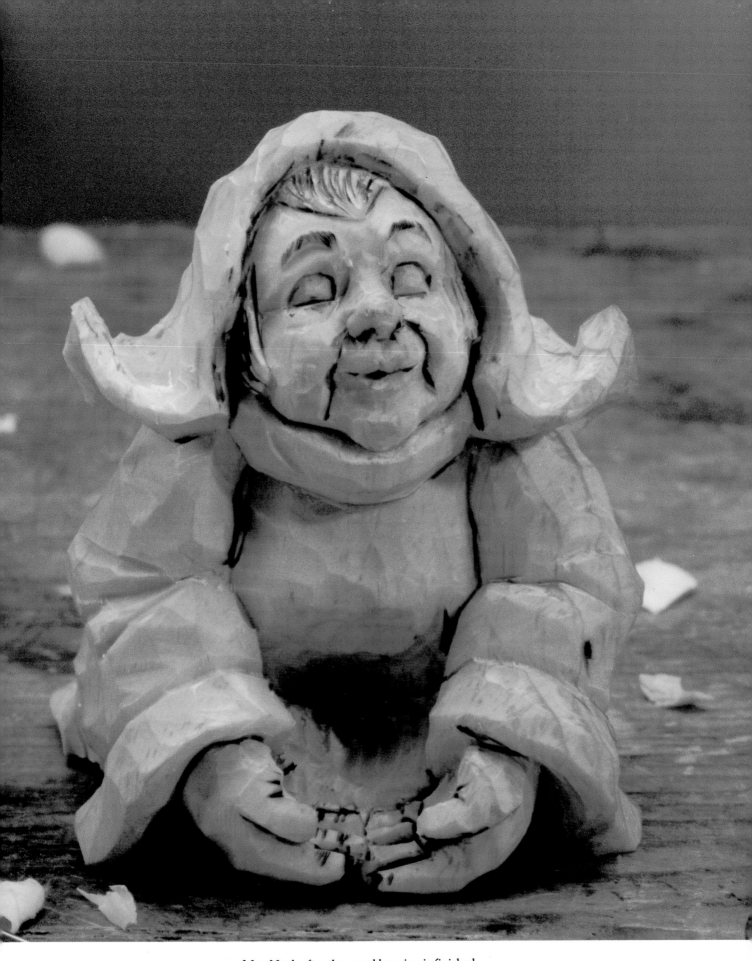

Mrs. Noah after the wood burning is finished.

Painting Mrs. Noah

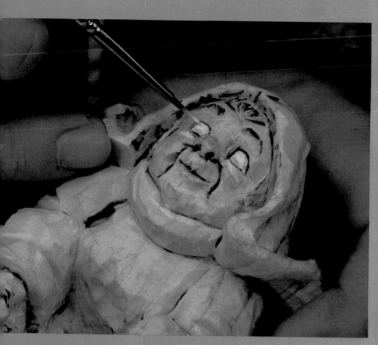

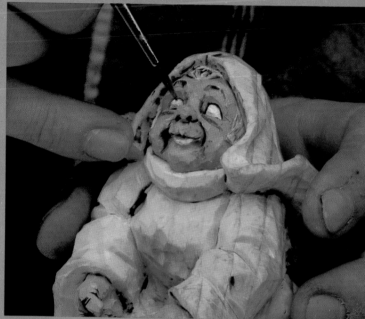

To paint Mrs. Noah we will use oil paints: flesh, cadmium yellow, white, black, raw sienna, brown ocher, burnt umber, ultramarine blue, cadmium red scarlet, warm sepia and cadmium yellow light. These are thinned with Minwax Natural and applied as a stain directly on the untreated wood. I like to use freezer paper with the shiny side up as my palette. First take a #1 brush and paint the eyes white.

Take the flesh, mix it with a little cadmium red and a little raw sienna, and apply it to the face and hands.

Mix a little brown ocher in the creases and folds of the skin to add dimension.

Mix a little cobalt blue, black, and burnt umber to create a bluish gray for the shawl.

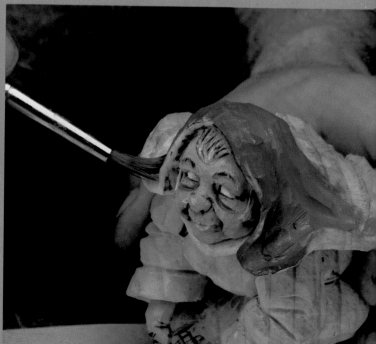

In the coarse of painting the shawl we will apply bold strokes of each color (cobalt blue, black, and burnt umber) directly into the folds to give the shawl some additional depth. Mix the colors directly on the subject as you go along. This adds extra life to the project.

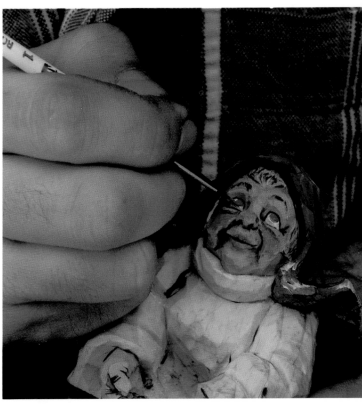

Mix cadmium blue and white for the iris' of the eyes. These will be looking up to the left. Rarely are full iris' seen. Paint them as if the upper part of each iris extends up under the lid.

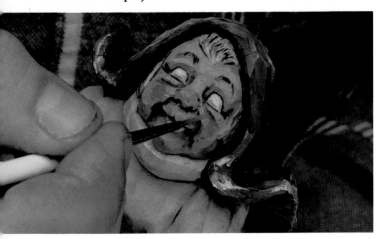

A little white will provide highlights along raised areas of the shawl. Then blend a little red scarlet into the cheeks. Minwax will allow you to blend it into the flesh tones.

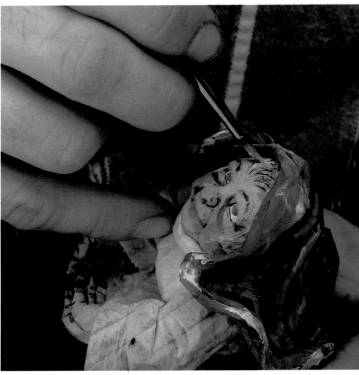

Mix a little black and raw sienna with white to create gray hair. Use this for Mrs. Noah's eyebrows as well.

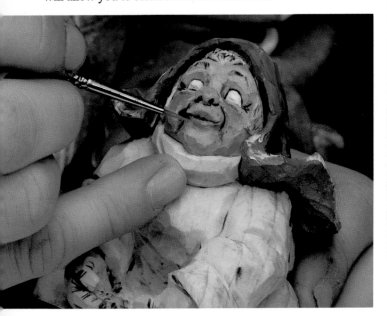

Carefully paint the lips cadmium red, thinned out.

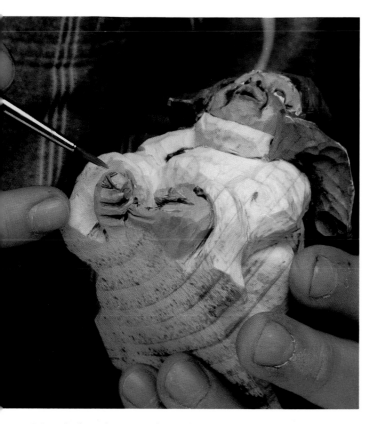

Mix a little cadmium red into the flesh tones along highlights of the hands. This is a very thin wash.

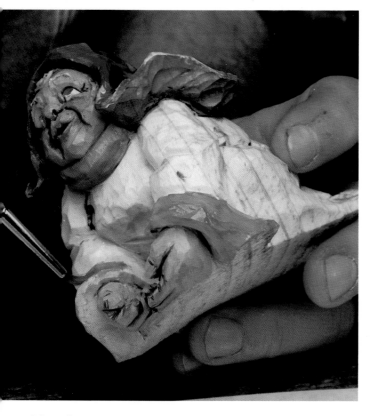

Mix yellow with a little burnt umber and brown ocher for the collar, sleeve cuffs, and shoes.

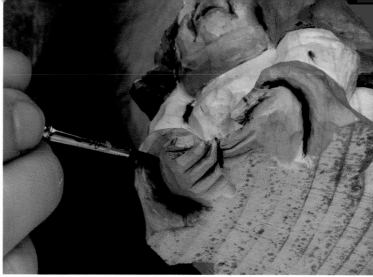

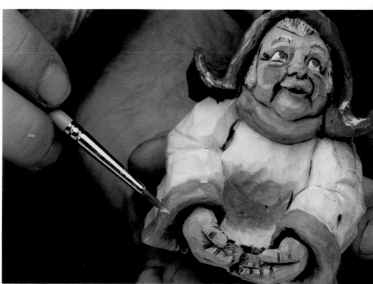

Take a little raw umber to create shadows within the sleeves.

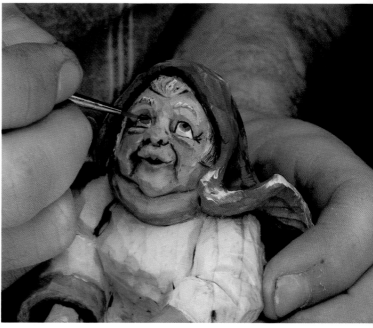

Cadmium yellow provides highlights to the cuffs.

Use just a touch of black on a small brush for each pupil.

Mix red with raw umber for the robe.

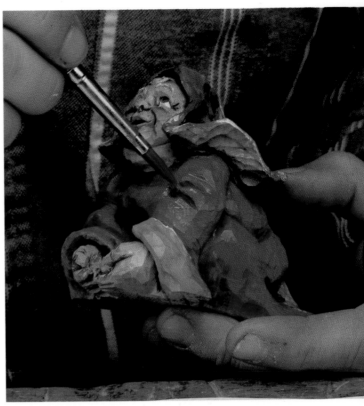

Use red scarlet to create highlights on the robe. Wiggle and slash them in quick strokes to portray light reflected off the fabric.

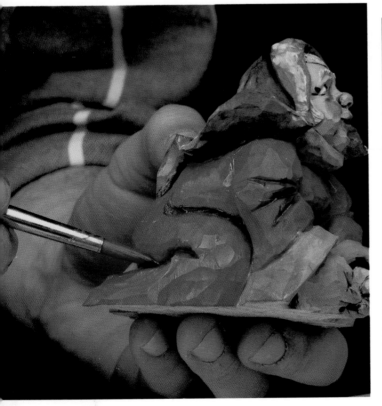

Put shadows in the creases with burnt umber.

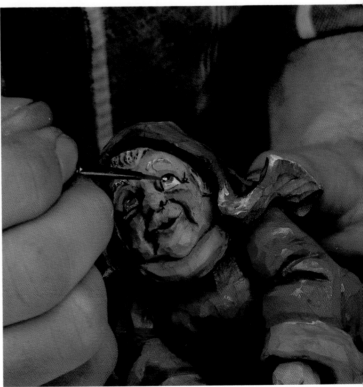

Use the #1 brush to place a small white dot in each eye. These dots are placed off to one side of the centerline of the eye. This adds sparkle and life to the eyes.

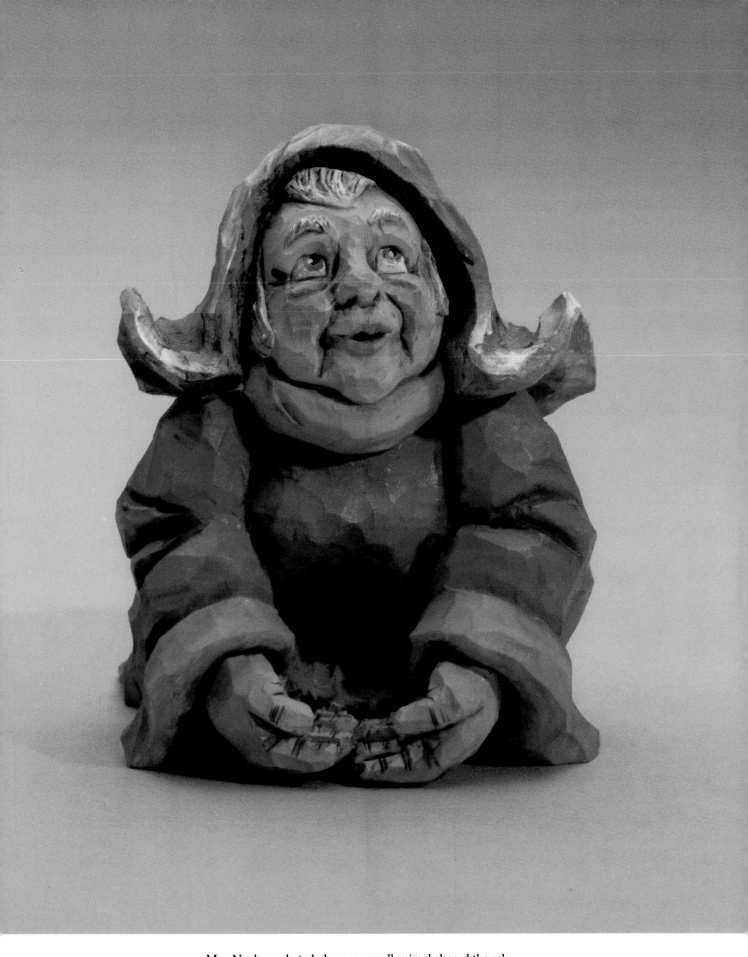

Mrs. Noah, ready to help some small animal aboard the ark.

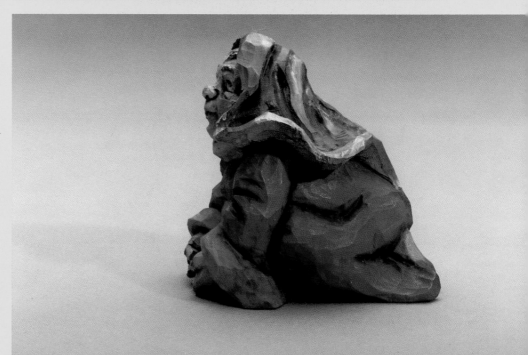

Carving the Puma

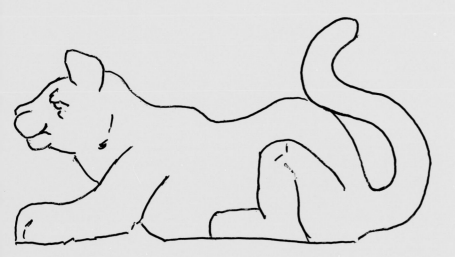

Transfer the puma's pattern to a block of pine and cut out the blank on your band saw. Now establish a center line down the back of the puma and trace in your patterns. We will start carving at the head. We will be using the bench knife, the #7 gouge, and the #15 V tool. First we are going to cut in the space between the ears. Make two vertical cuts down along the inside edges of the ears to the top of the head. Then make a horizontal cut at the level of the top of the head between the two vertical cuts to pop out the chip from between the ears.

Take the #7 fishtail gouge and start rounding in toward the nose.

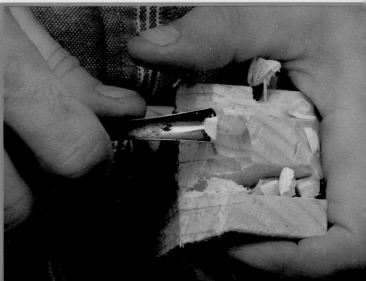

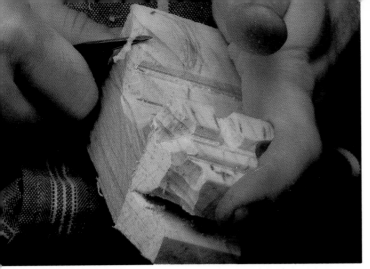

To make the puma more comfortable to handle, round off all the sharp edges with the bench knife.

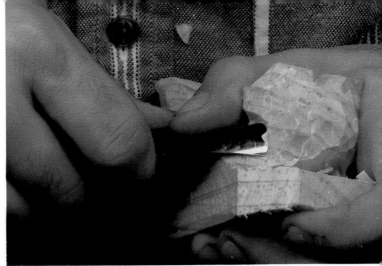

Start narrowing down the head, using the #7 gouge. Pumas have a somewhat "boxy" shape to their heads with relatively short muzzles. Begin reducing the neck as well to reveal the lower jaw.

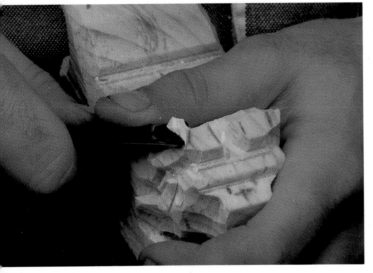

The ears are going to be slightly bent forward. Remove some wood from the back of the ears with the #7 fishtail gouge.

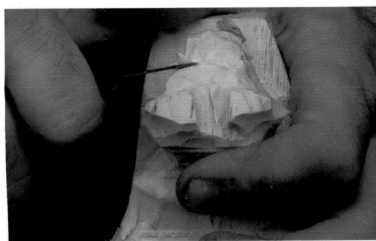

With a bench knife you may further refine the features.

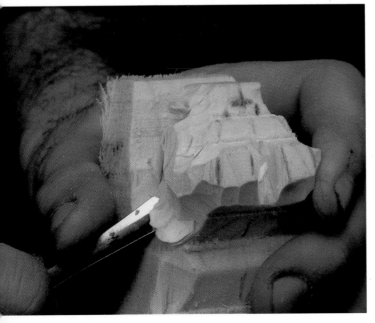

Work under the ears to define their lower limits.

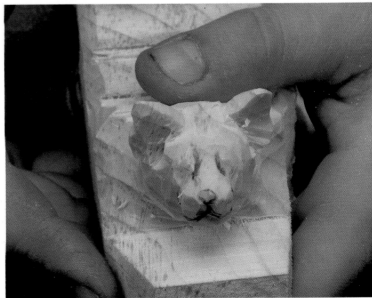

Once you have the head reduced it is time to find the eyes, nose and muzzle. Draw in the pencil lines along the insides of the eyes leading to the forehead, and the nose, and mouth.

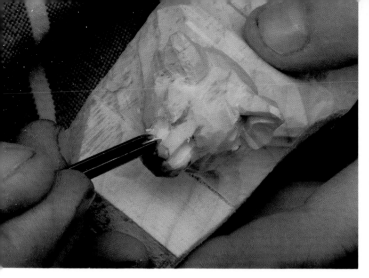

Run a #11 gouge from the tip of the nose toward the eyes along both sides. These cuts will leave a central ridge.

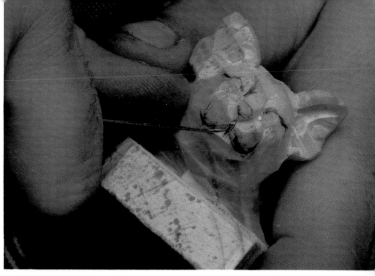

Next make stop cuts along the pencil lines of the upper jowls to begin to create the lower jaw.

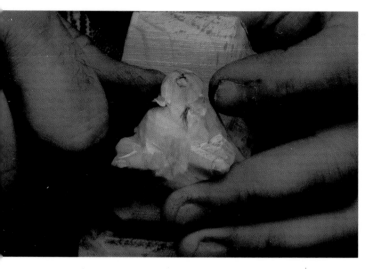

Follow the pencil lines along the insides of the eyes leading to the forehead with the bench knife, creating two stop cuts. Then make room for the eye sockets by cutting a nice flat, forward facing surface for each eye. The knife tip will follow the stop cuts down along the inside edges of the eyes.

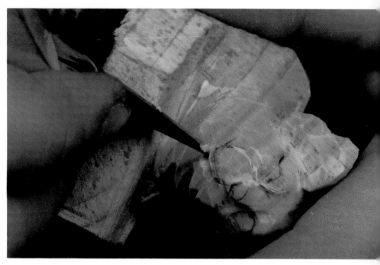

Then follow the stop cut, running your blade straight up below the jowl to create the lower jaw.

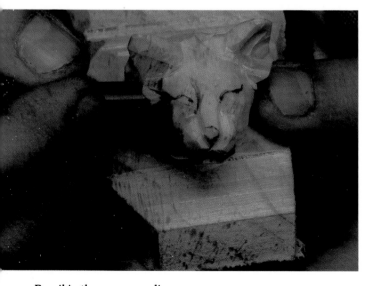

Pencil in the upper eye lines.

Use the #9 gouge to delineate the throat and lower jaw bones.

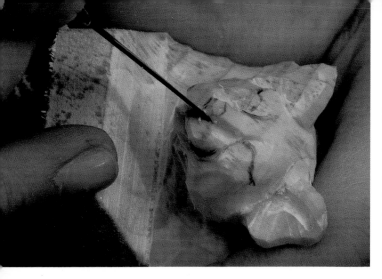

Three stop cuts shaped like a Y with the bench knife will delineate the nose and the space between the jowls.

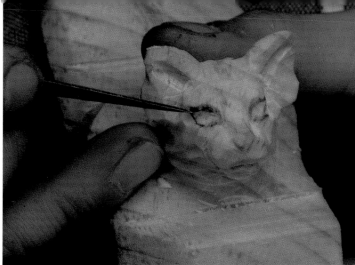

To create the puma's eyes, first make sure the eyes are well drawn in pencil. The eyes should be slanted a little to create an intense stalking stare.

Make little knife cuts with the very tip of the bench knife underneath the nose up to the stop cuts. This will make the nose stand out.

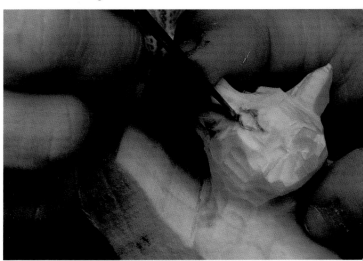

Using the tip of the bench knife cut straight in, following the pencil lines all the way around the eye.

Use the small V tool to define the jowls with a single curved cut following the stop cuts on each side.

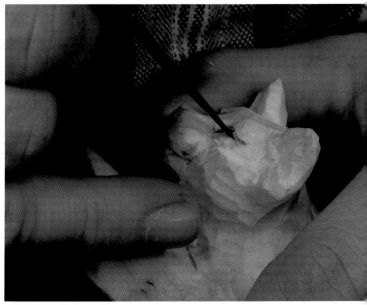

Then round the eyeballs off, cutting at an angle back toward the stop cuts you just created at the eyelids.

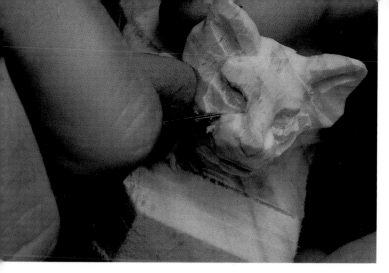

Using the tip of the bench knife cut in the lower eyelids, making a small cut from the far corner of the eye around to the inner corner.

Begin rounding down the paws themselves. I like to leave the paws big to accentuate the puma's features.

Moving on to the front paws, the left front paw will be extended while the right front paw is pulled back into the body. Draw in the pattern guide lines for the paws. Pumas have fairly large paws. We will accentuate that. Using the bench knife, begin removing the excess wood from the paws.

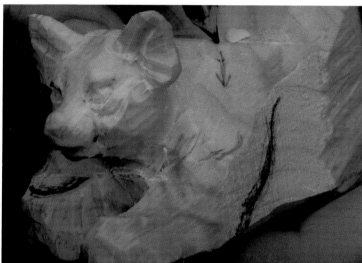

Use the bench knife to dip the left front shoulder down in reaction to the extended front paw. Follow the arrow.

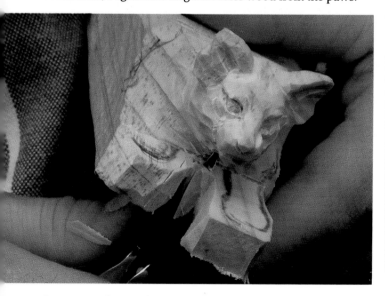

Continue reducing the wood around the paws.

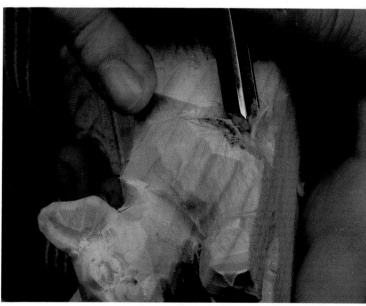

Use the #15 V tool to outline the back of the left leg. Begin removing excess wood from behind the leg.

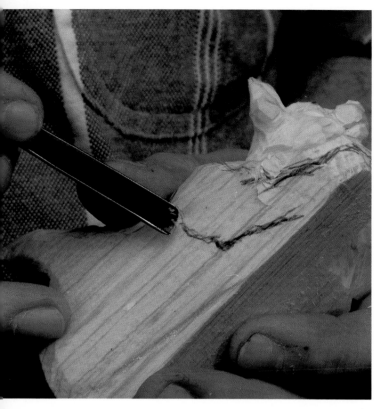

Draw in the right front leg and follow the line with the #15 V tool.

Keep the right front shoulder high to show the leg pulled back on the right.

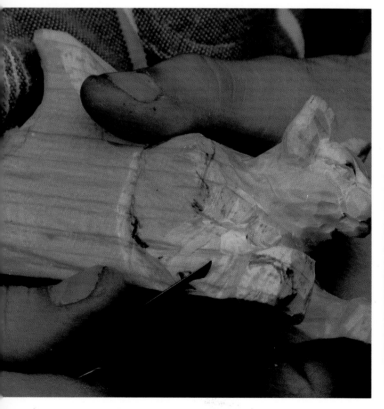

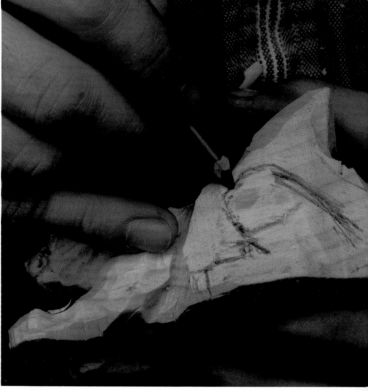

Once the right front leg has been outlined, reduce the leg with the bench knife.

Moving back along the flanks, sketch in the hind quarters.

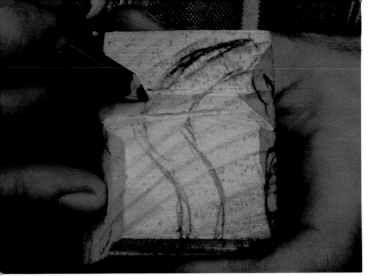

Also draw in the waving tail.

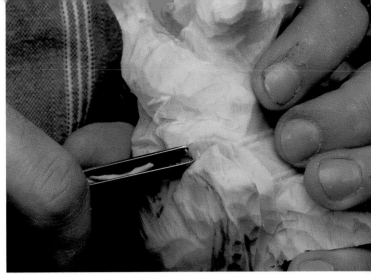

Follow the pencil lines with a #15 V shaped gouge to define the haunches.

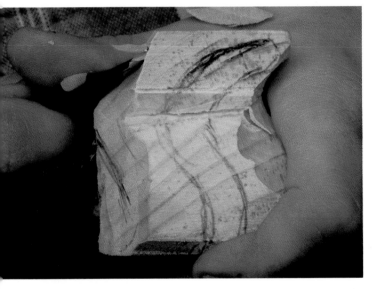

Using the #7 fishtail gouge again, remove enough wood from the tail to begin to define the haunches.

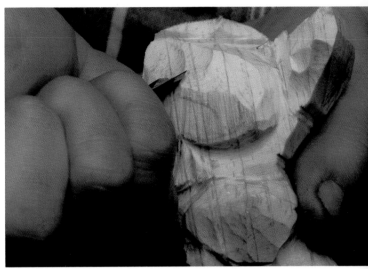

Round down the haunches with the #7 fishtail gouge, tapering toward the tail in the rear.

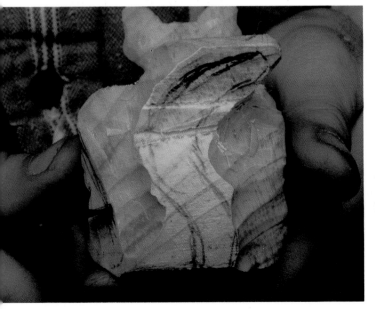

Don't remove too much from the area of the tail just yet, however. We don't want any broken tails.

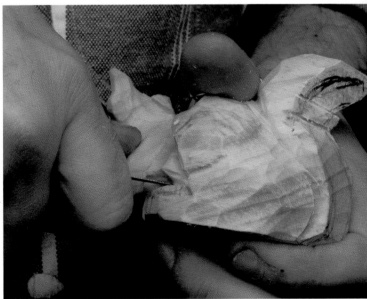

Make a deep stop cut along the front of the rear legs and paws to begin to separate them from the body on both sides.

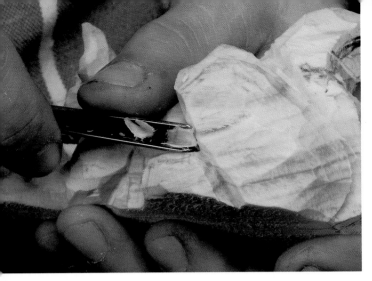

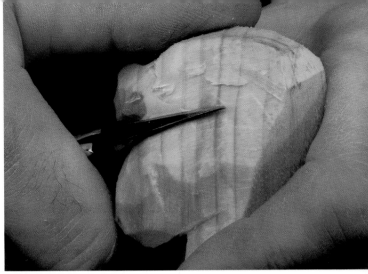

Using the #15 V tool, separate the hind feet from the haunches to give them the appearance of coming out from underneath the haunches.

Round the haunches down with the bench knife. You want the knees sticking out.

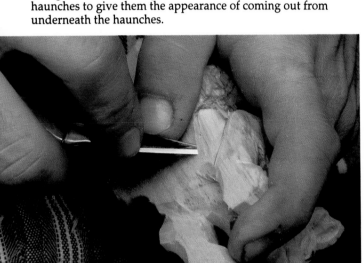

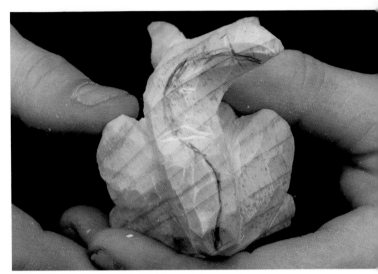

Undercut the front legs with the bench knife to shape the underbelly.

We need to find the tail. Draw in a center line with a pencil as a guide to the curve of the tail.

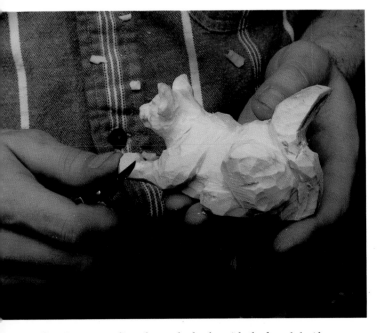

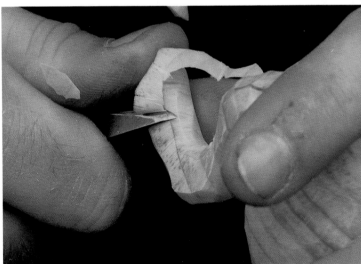

Continue rounding down the body with the bench knife.

Begin to work in from the tail tip, the thinnest part. Ride the bevel of the bench knife to make the curves in the tail. Just feel the curve with the blade and make nice long smooth cuts. Be sure to support the tail with your other hand as you cut to keep it from breaking.

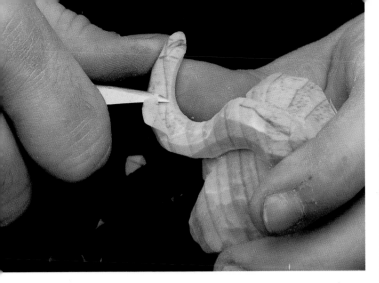

Continue reducing the tail.

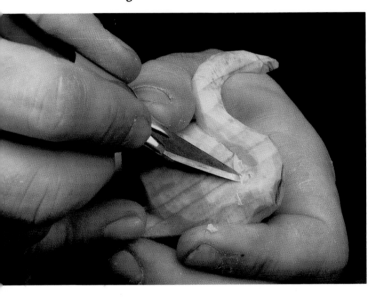

Use the bench knife to separate part of the tail near it's base from the hind quarters. Cut a small half circle around the inside of the tail while following the curvature of the rump as well. Slowly cut through the excess wood.

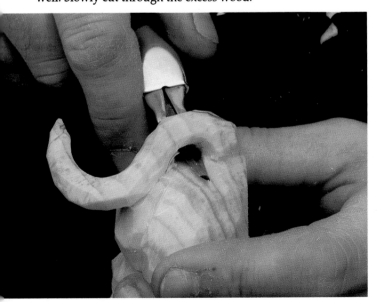

The tail is freed.

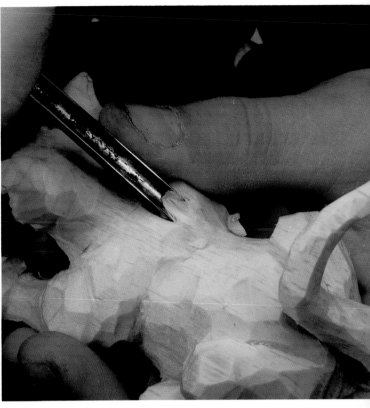

Make one nice deep cut with the #9 gouge between the spine and the shoulder blade. This will give us a nice raised shoulder blade and help create a "ready to pounce" stance.

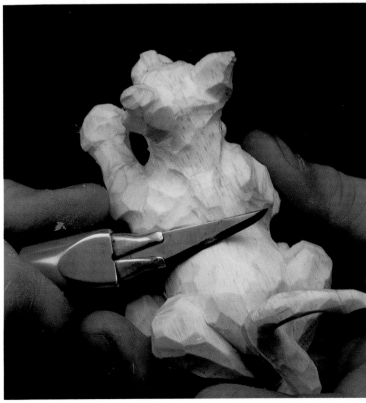

Note the angle of the shoulders created by this stance as indicated by the straight edge of the bench knife.

31

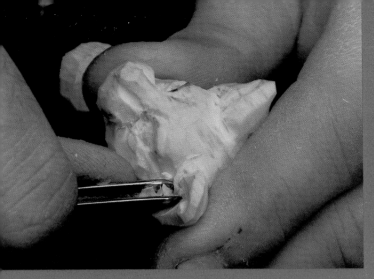

Using a #11 gouge, hollow out the inside of the ears while carefully supporting them from behind.

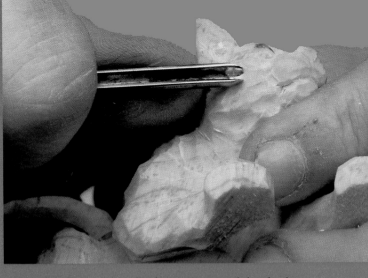

Using the #11 gouge, make short cuts around the cheeks to indicate fur.

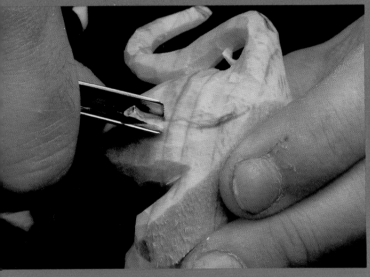

Draw in an S shaped pencil line for the crease between the upper and lower leg. Follow this line with the #15 V tool to create the crease.

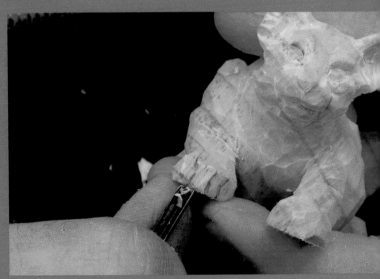

Moving to the paws, draw in guide lines for the claws and cut them in with the #12 V tool.

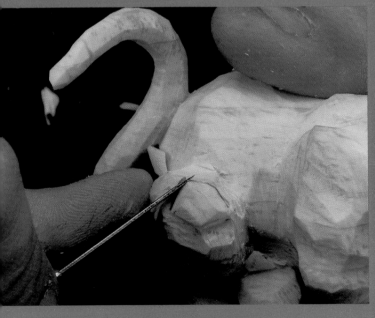

Recess around the knee with the bench knife as shown here.

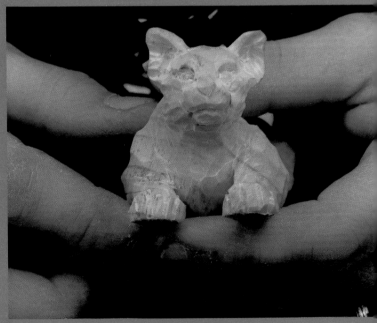

The carved claws.

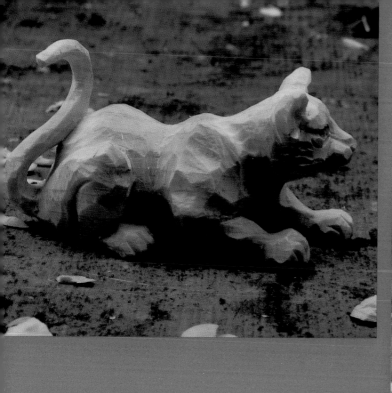

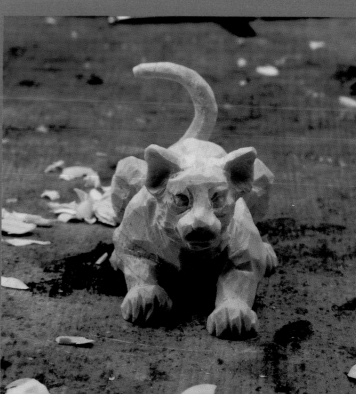

The carved puma ready for paint.

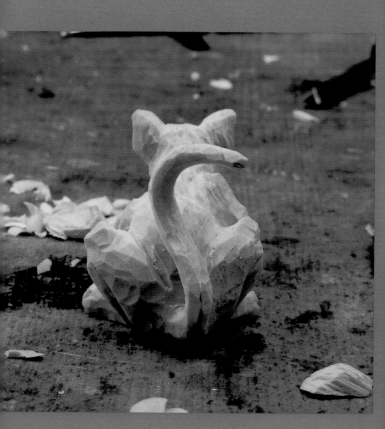

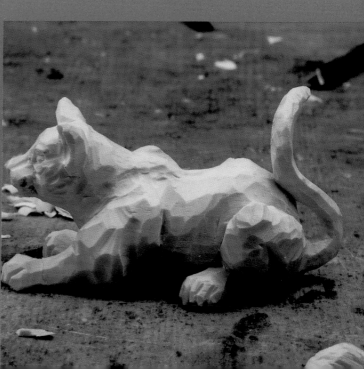

Painting the Puma

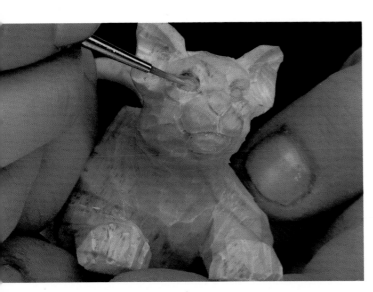

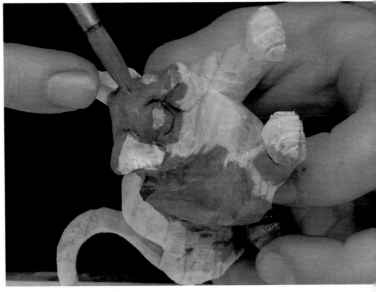

Once again, the puma is painted oil stains created by mixing Minwax with the oil paints. This mix is applied directly on the carved wood. We will use white, black, red scarlet, cadmium red, raw sienna, warm sepia ultramarine blue, brown ocher and cadmium yellow. For the eyes use cadmium yellow and a little raw sienna. Apply this carefully with a small brush.

Mix a little red scarlet and white for the pale pink of the puma's nose. Pumas have very pale pinkish noses.

For a good body color mix brown ocher, raw sienna, a little bit of ultramarine blue and just a hint of white. This will produce a very nice "sandy-ish" color. Don't mix these colors too thoroughly as we want varying shades throughout the body to produce a nice fur effect. Apply the paint lightly everywhere except the insides of the ears, the cheeks, the chest, the underside of the body and the insides of the front legs. These will be a light beige.

Mix some white with raw sienna and warm sepia to create a light beige color. Paint the inside of the ears, the cheeks, the chest, the underside of the body and the insides of the front legs beige.

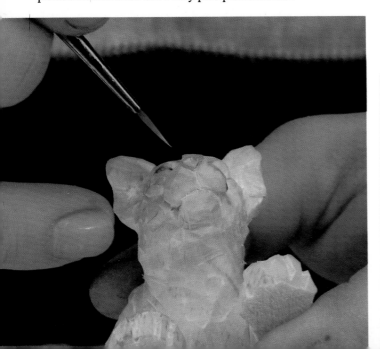

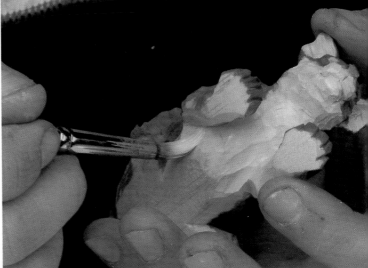

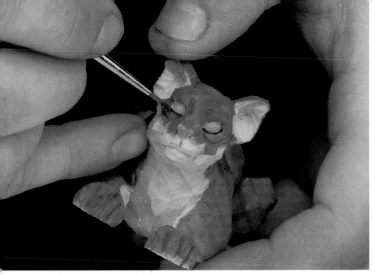

Outline the eyes with warm sepia using the #1 brush.

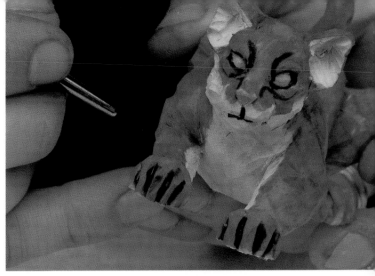

With a #4 brush apply warm sepia to the claws.

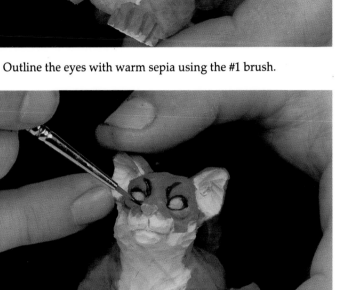

Paint the jowls, nose, and the lines extending upward from the inside edges of the eyes with the warm sepia as well.

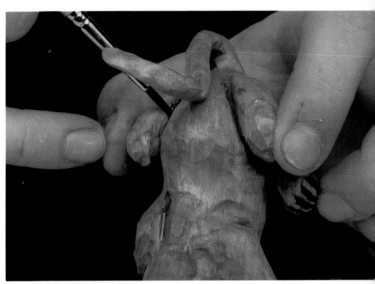

Continue to use the warm sepia and the #4 brush to outline the haunches. Blend the paint in to create a shadow effect.

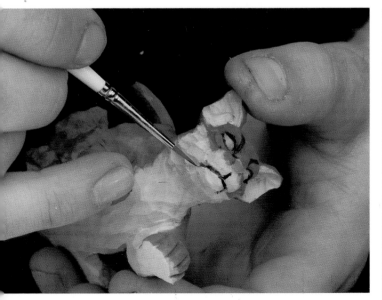

Outline the mouth and the separation under the nose with warm sepia. Turn the corners of the mouth down slightly for a predatory look.

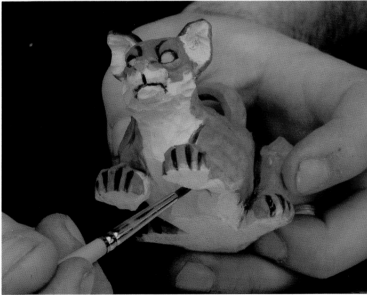

Use the warm sepia along the top of the ears and where the front legs meet the chest.

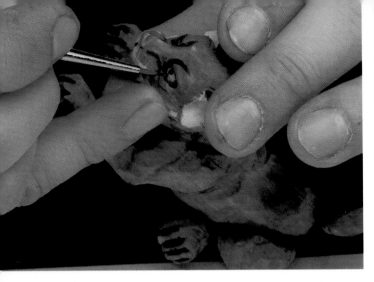

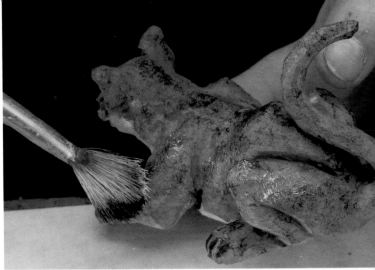

Take the #1 brush and a small amount of black to paint the iris'. Be careful to make both eyes look straight ahead.

Create mixed highlights in some areas by using the fan brush with a little white, black, and blue. Just apply little touches of each color along high spots. This is to suggest the sun glistening off the fur.

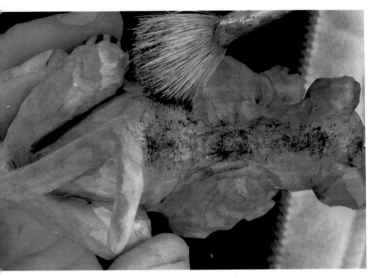

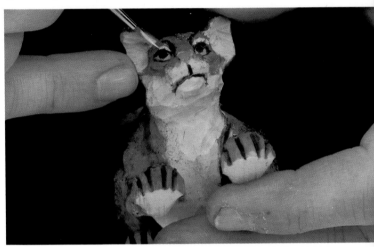

Now dab the tips of the bristles of a fan blender in warm sepia and stipple a line going down the center of the puma's back. Continue stippling the back until you have a dark band down the center. Have fun.

Take the #1 brush and some of the light beige mix we used on the belly and paint a little line along the top of the eyelids.

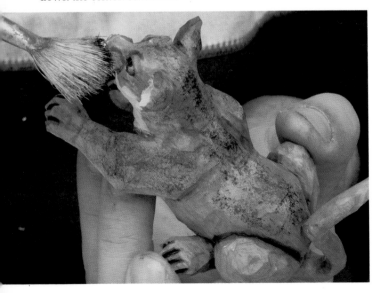

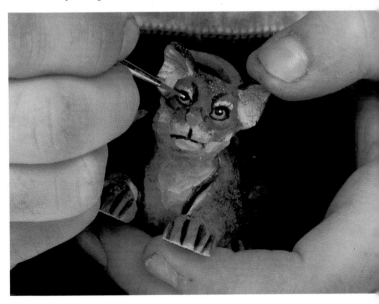

Lightly dab the warm sepia around the body and jowls of the puma. This creates a furry effect. Don't forget the tail.

Clean the #1 brush and use it to put highlights in the eyes. Use pure white straight out of the tube for this. Place a single dot above the center line and off center in each eye.

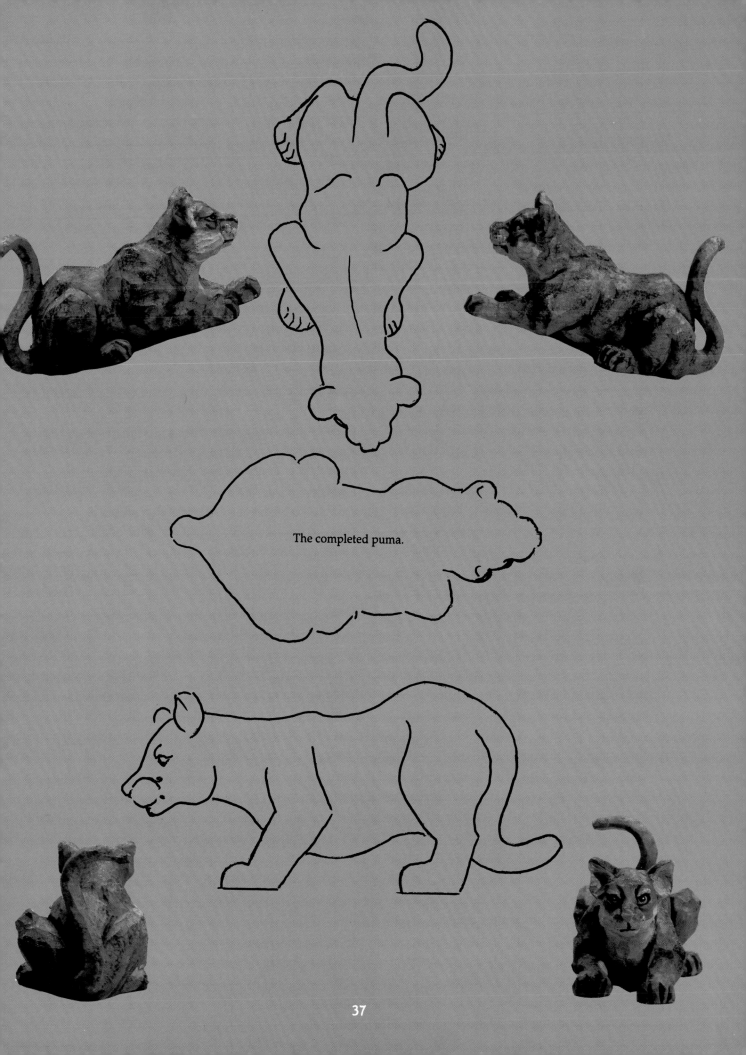

The completed puma.

Carving the Turkey

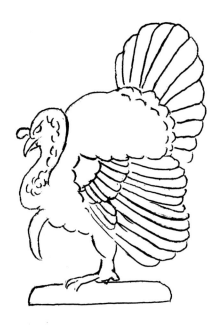

Transfer the turkey pattern to a 2 1/2" wide block of white pine. Cut out the blank on your bandsaw. Establish a center line on the blank. Use the #7 fishtail gouge and establish the width of the head and undercut the chest, rounding the chest as you go.

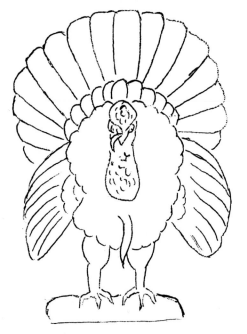

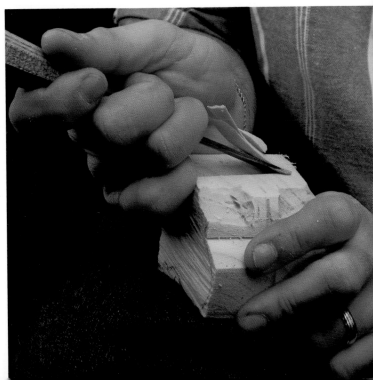

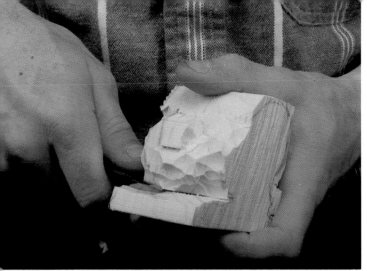

The chest is undercut and the head established.

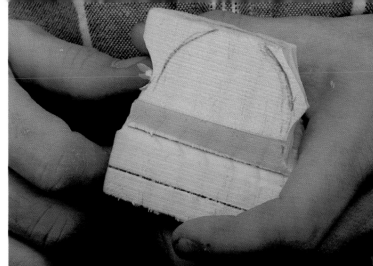

Draw the fan shape of the tail on the back of the wood block to help round the tail.

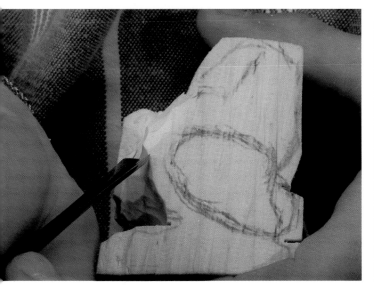

Draw the wings on the side view. Take the #7 fishtail gouge and carve the excess wood away from around the wings. The wings taper in to the front and pull away from the body in the back. Leave a lot of wood at the back for these flared wings. Also remember that the body is rounded.

This is a good time to round back the tail with the #7 fishtail gouge as well. The tail is angled back. Come in on a diagonal cut, sloping away from front to back. The small pencil line indicates the location of the base of the tail and the larger line the tip of the feathers.

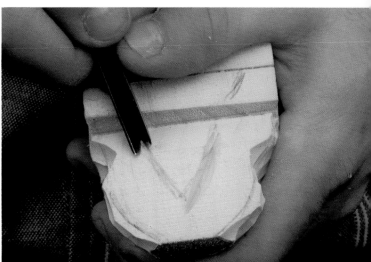

Draw in the inverted V shape of the turkey's lower rump feathers. Follow this line with the #15 V tool to create the intersection of the tail and rump feathers.

Once the inverted V is established, scoop out the excess wood from the back of the tail feathers with the #7 fishtail gouge.

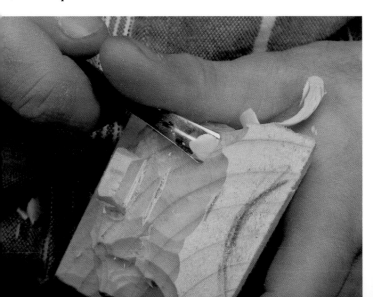

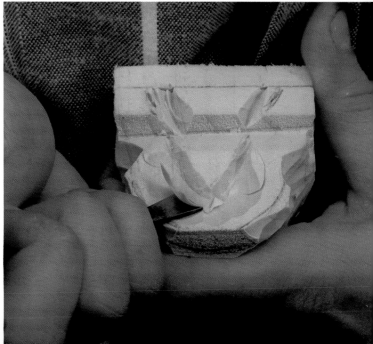

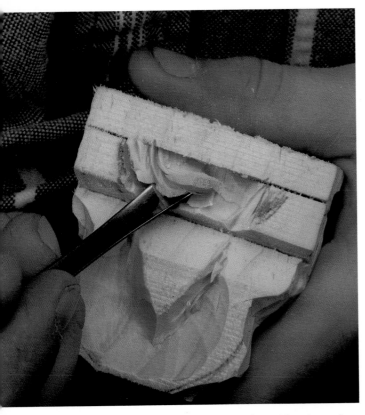

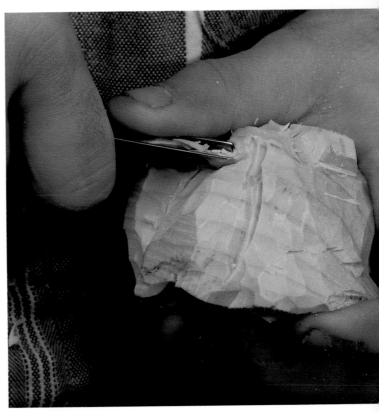

The two small pencil lines here represent the inside edges of the primary wing feathers. Between these lines carve out the area that will give us the back of the legs. The legs will be roughly 1/3 of the way under the body from the back, 2/3 from the front. Carve in a little less than necessary from the back with the #7 fishtail gouge for now. The legs are the supporting structure while the body is being carved and need to remain sturdy.

Use the #15 V tool to provide some separation between the body and the wings.

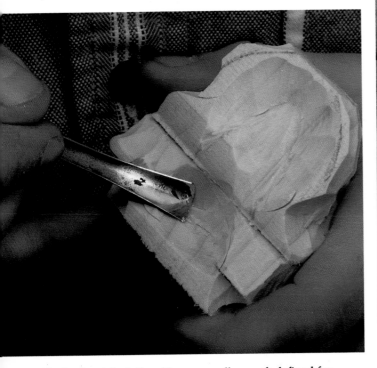

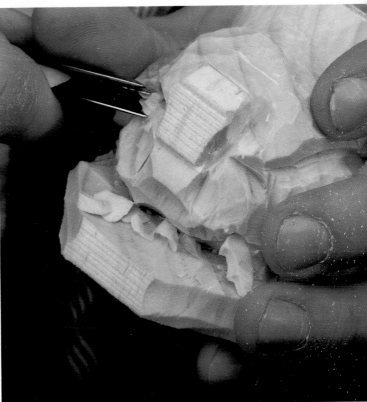

The backs of the tail and legs are well enough defined for now.

Using the side of the #15 V tool as a straight chisel, establish and begin to round the puffed up front chest feathers of this strutting male. Be sure to leave enough wood for the long wrinkled neck.

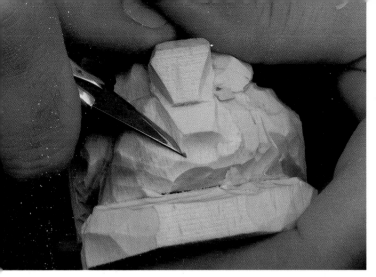

Using the bench knife, round the turkey.

Round the cheeks. This is very close knife work.

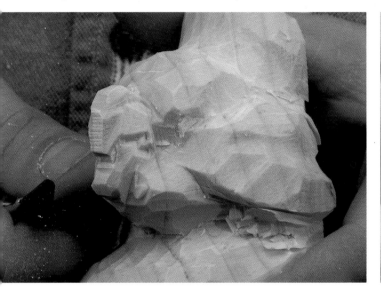

Continue rounding the bird.

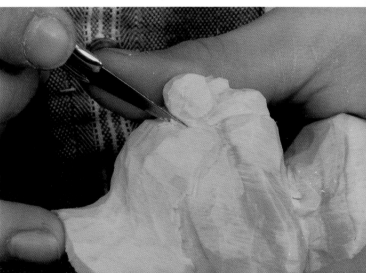

Undercut the head a little to define the shape and curve of the neck and the back of the head.

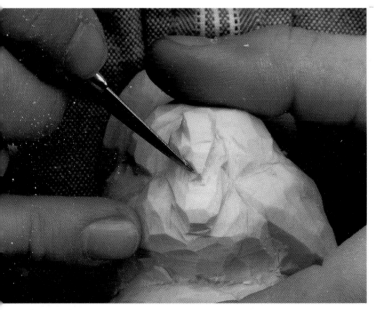

Use the bench knife to carve small indentations for the eyes, cheeks, and beak. Make a little V cut behind the neck to establish the size of the head as well.

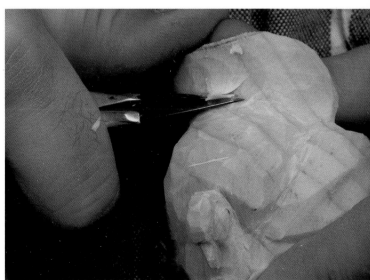

There is a transitional area between the turkey's back and his tail. Using the bench knife, begin at the back, beveling the blade and pulling it up tight onto the tail feathers to make a little hollow.

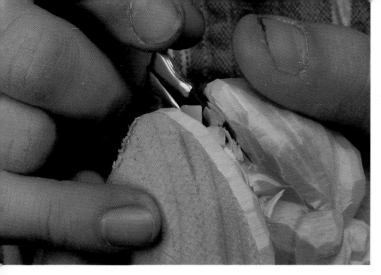

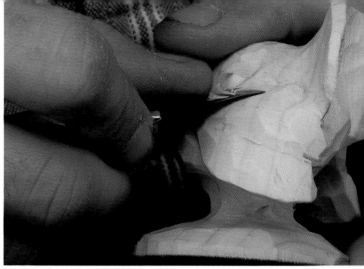

Undercut the wings. Leave about a 1/2" post 2/3 of the way under the front of the turkey's body for the legs. We won't thin the legs until we are ready to carve the feet at the end of the project.

...like this.

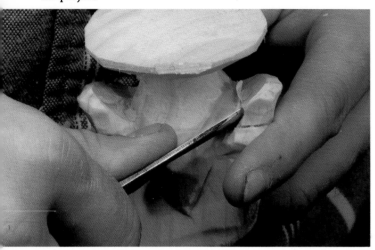

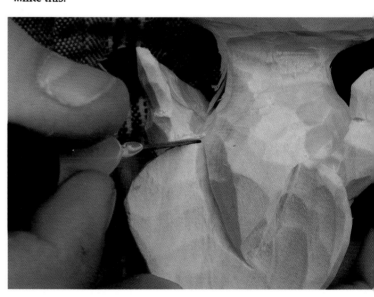

To get the inner curve of the wing, use the #7 fishtail gouge to scoop out the excess wood in the same way we did with the tail.

Make a small V cut at the base of the tail with the bench knife, separating the tail from the body.

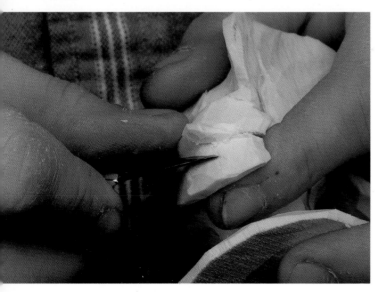

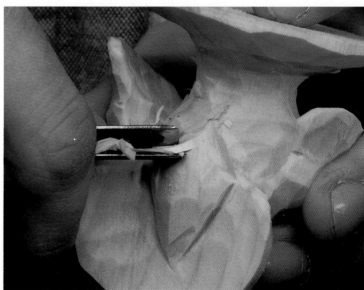

Thin down the wings, supporting them as you work. The secondary feathers overlap the primaries creating two mounds on the wings...

This is the transition from the side feathers to the flank feathers. Use the #15 V tool to carve this small V. Then take the bench knife...

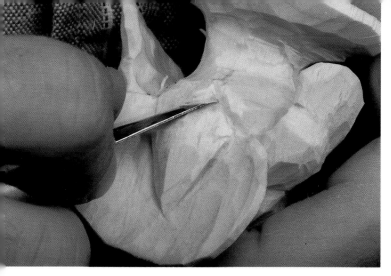

...and blend the cut into the transitional feathers.

Using the bench knife, separate the primary feathers by making small angled cuts at the end of each feather, tapering each into the feather above it.

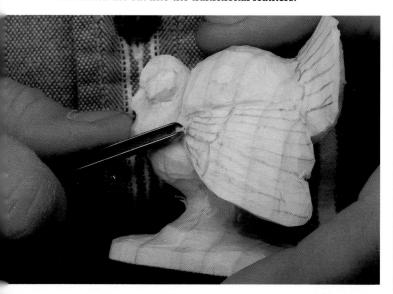

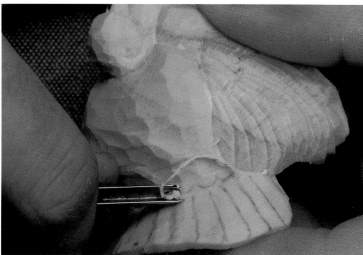

This is where the tail feathers enter the body. These are the tail coverts. Cut them in with the small V tool, using the side of the V tool in the same way we did with the tail feathers.

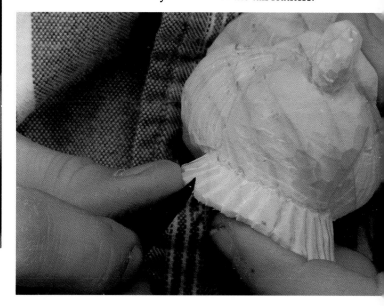

It's time to put in both the secondary and primary wing feathers. First draw in the feathers. Then use the #12 V tool, follow the pencil lines, and make small curving cuts to simulate feathers. Hold the chisel on it's side while carving. This will create the impression that the feathers overlap from top to bottom as the chisel undercuts the wood above.

Repeat the carving techniques used on the wing feathers for the tail feathers.

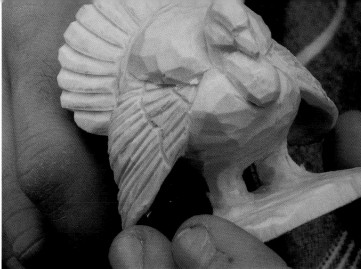

Repeat the process on the back of the tail feathers as well, using either the very tip of your bench knife or a small V tool. Support the tail with your other hand and be careful not to cut through the tail.

The legs are separated.

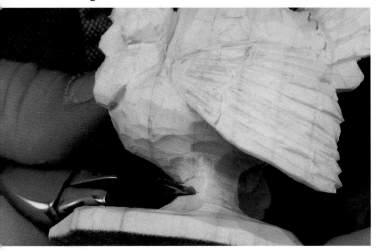

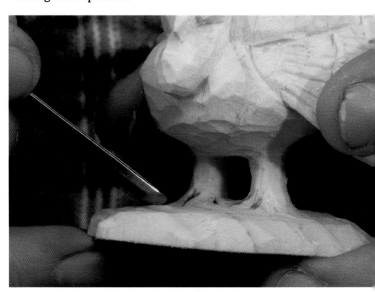

It is time to carve the legs. Start by thinning them down with the tip of the bench knife, preparing to put in the separation between the two legs.

Further reduce the size of the legs while remembering to leave enough wood to support the turkey. Once the legs are reduced draw in little pencil lines for the toes and make little V cuts between them with a small V gouge.

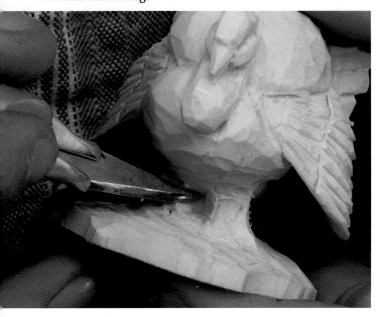

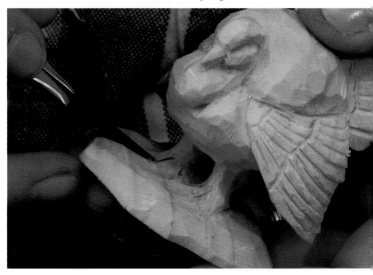

Begin carefully separating the legs.

Use the bench knife now to recess the ground around the toes. It is up to the bravery of the individual carver now to decide how much thinner to make the legs as well.

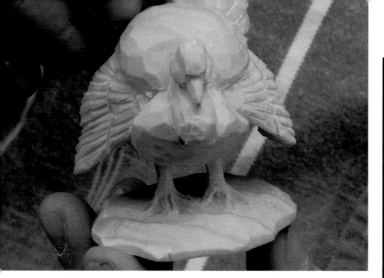

This is thin enough for me.

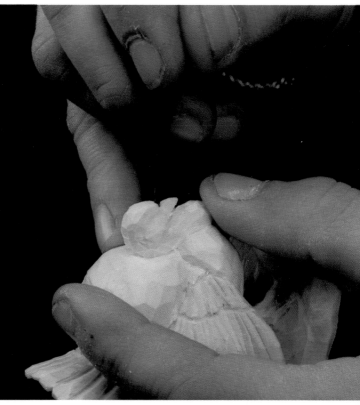

Make a small hole at the top of the beak for the wattle.

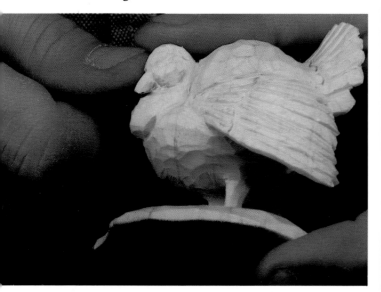

Undercut the beak a little with the bench knife.

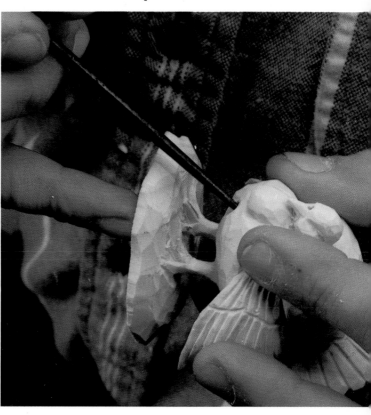

Repeat the process in the middle of the chest for the beard.

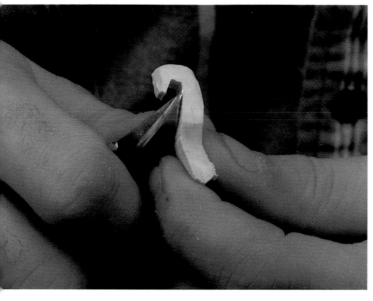

Time to carve this male turkey's wattle and beard. These are carved separate from the body of the turkey and applied. For ease of carving, do the rough work with both pieces together in this simple crooked shape.

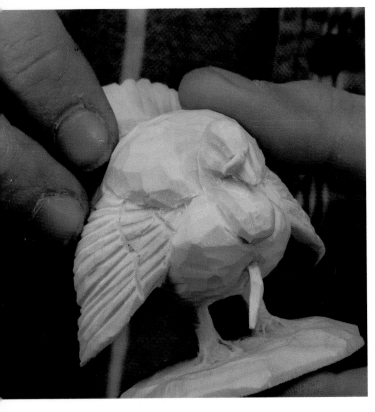

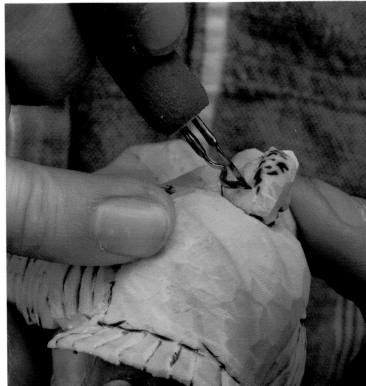

Using a little epoxy, apply the wattle and beard. The crooked end of the piece we carved earlier is cut loose and becomes the wattle. The longer tail becomes the beard.

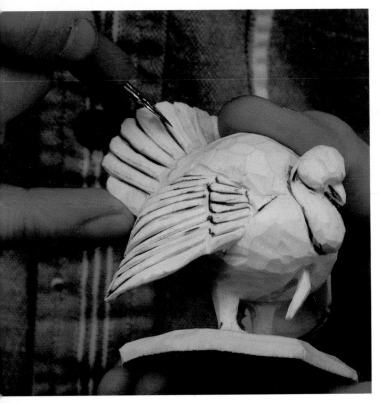

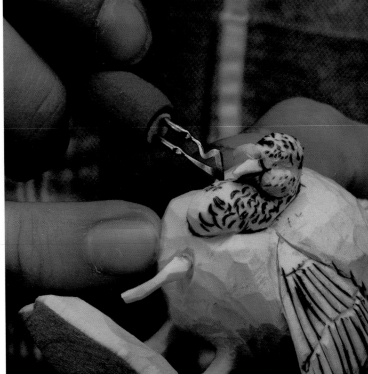

Also use the wood burner to create the knotty appearance of the turkey's head and neck.

Use the wood burner to clean up the cuts along the feathers, and around the neck, beak, and feet. This will take care of any wood fibers that were left standing up after the carving.

Painting the Turkey

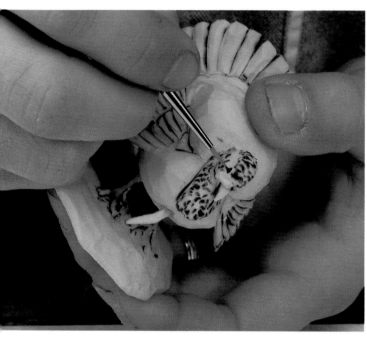

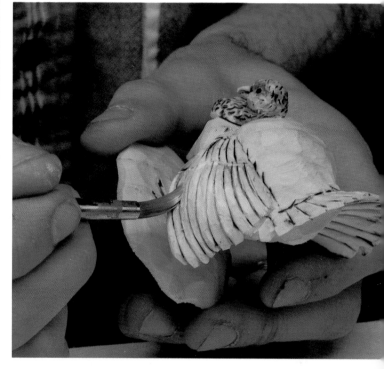

Time to paint the turkey. Once again, the oil paints are mixed with Minwax to produce colored stains. We will use brown ocher, black, white, ultramarine blue, cadmium yellow, green pale, warm sepia, cadmium orange, raw umber and raw sienna. First we'll paint the eyes black with the #1 brush.

Take a little white, mix in ultramarine blue, and a little black for the head color. Apply with a #4 brush and paint the wattle as well.

Use a lot of white and a little raw umber to paint the wing feathers. This will also work for the underside of the wings.

Mix a little black with cadmium red and paint the bottom of the neck.

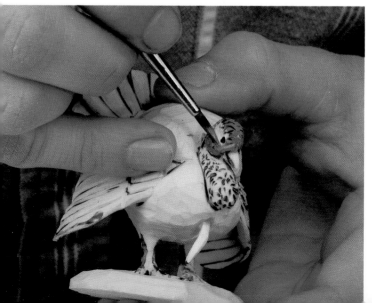

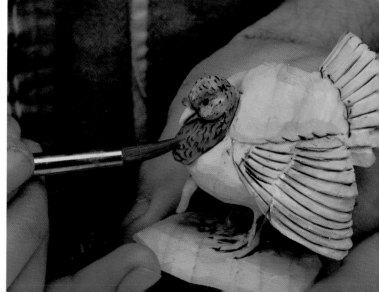

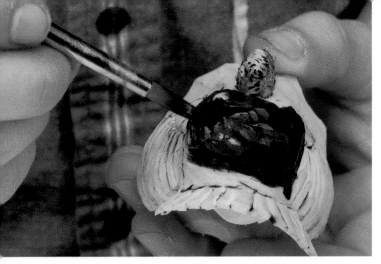

Use a mix of ultramarine blue, black, and raw umber to paint a base coat on the body, breast, and underbelly of this bird.

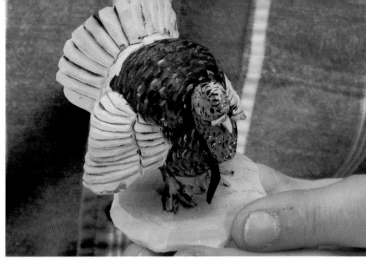

The painted body.

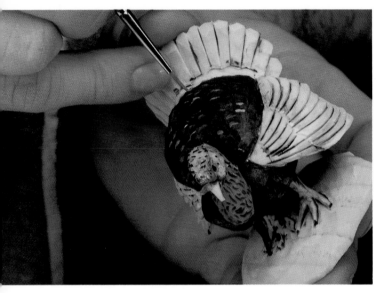

While the base coat is still wet use cadmium orange, pale green, and a little yellow to produce iridescent highlights. This is done in little half strokes with a small #1 brush, mixing the colors into the blue. We are trying to recreate the iridescent bronze of turkeys. Don't make these colors too pronounced.

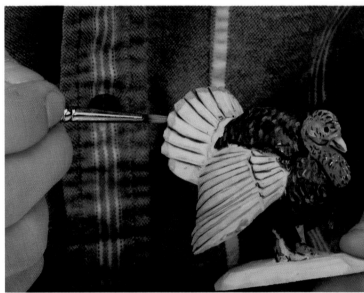

Use raw sienna, white, and a touch of a cadmium yellow to produce the color for the outside band of the tail. Repeat on the back side of the tail.

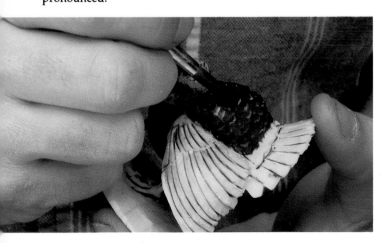

Go back with the #8 brush dipped only in Minwax and dab the brush over these little splashes of color to mute them. Pull the colors down into the background color. Repeat this process on the chest and underside of the bird.

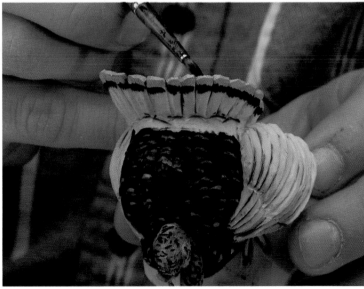

Apply a black band to both sides of the tail feathers beneath the outside band.

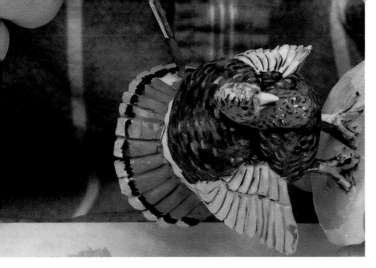

Next mix brown ocher with a little cadmium red and paint the remaining parts of the tail feathers on both sides.

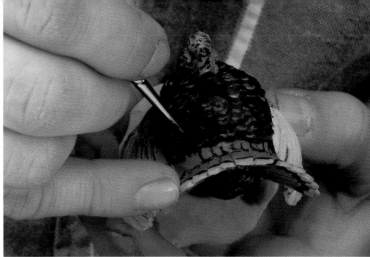

Take a little black on the #1 brush and outline the tail coverts.

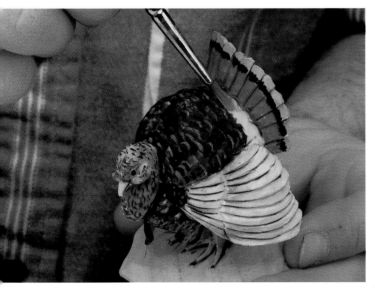

Use the same color for the transitional feathers.

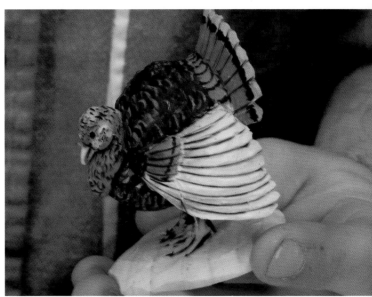

Put little black bars on the wing coverts as well.

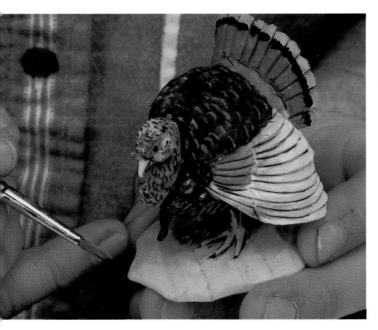

Mix raw sienna, cadmium red and some orange. Paint the secondary wing coverts.

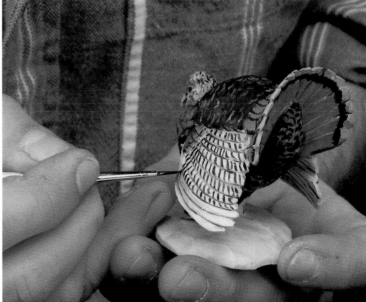

On both sides of the wings paint little black bars that angle back toward the ends of the feathers with the #1 brush.

For the fine irregular lines on both sides of the tail, simply use a pencil.

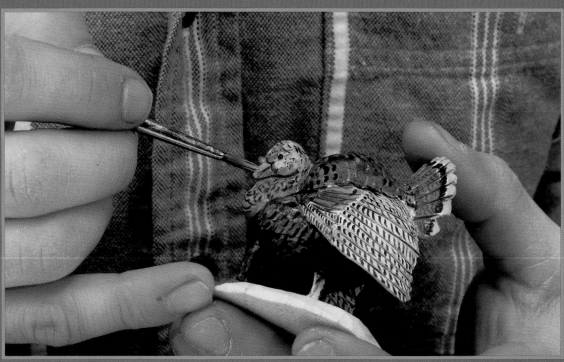

Mix a little raw sienna and white for the beak. You may give the beak a white tip if you like.

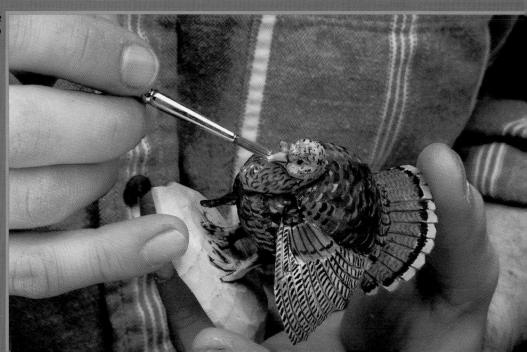

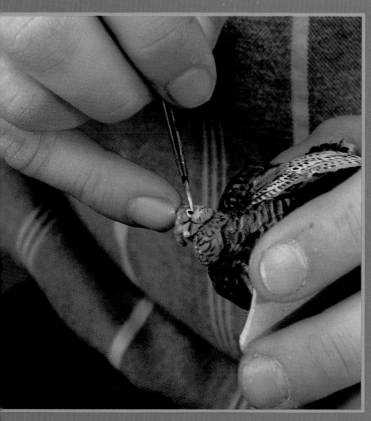

Mix a little black with white. Apply the light gray around the eyes.

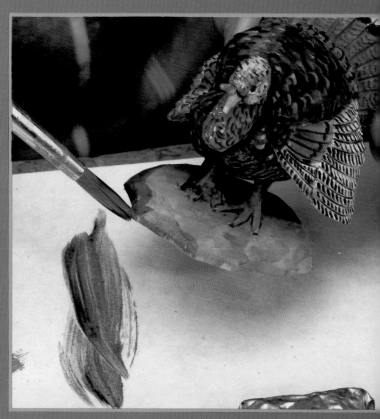

Mix some brown, green, raw sienna, and whatever else is on your palette to produce a little complimentary ground color.

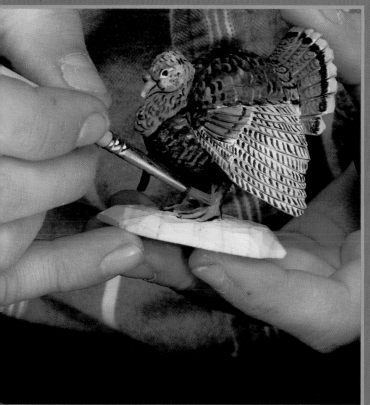

Mix scarlet red, yellow, and white for the feet.

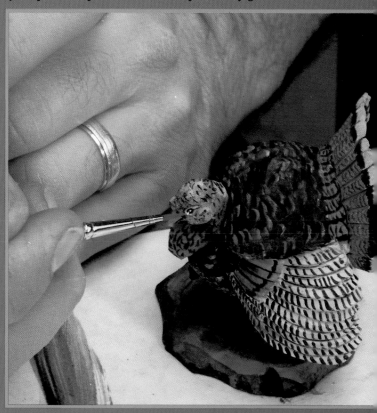

Place a little white dot in each eye with the fine #1 brush to add life to the eyes.

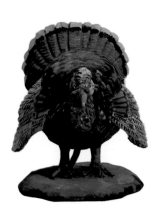

The finished turkey.

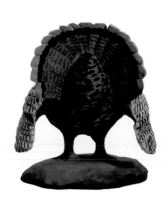

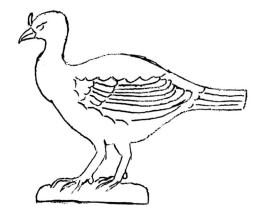

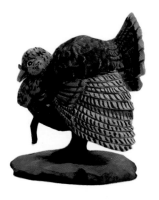

The Gallery

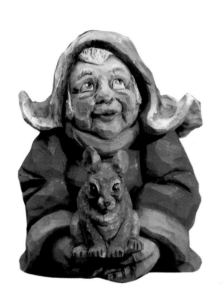

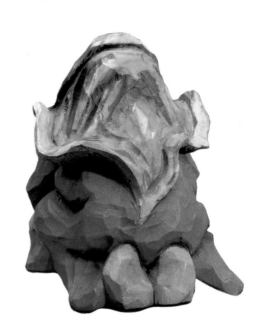

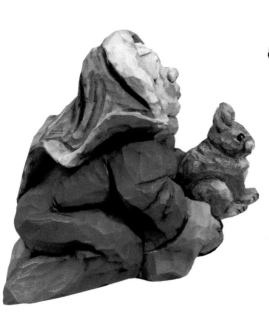

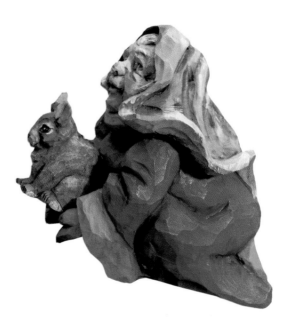

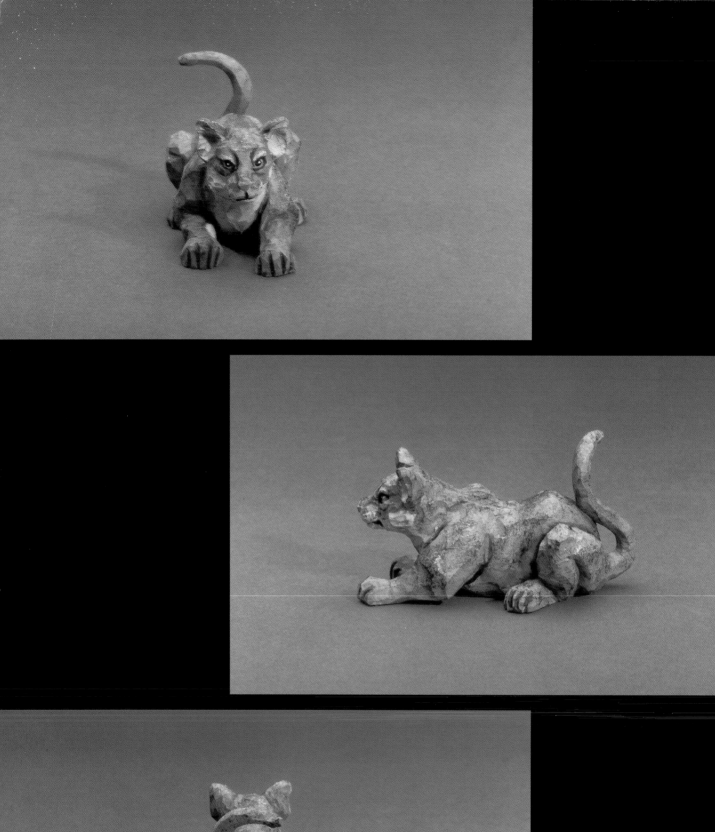
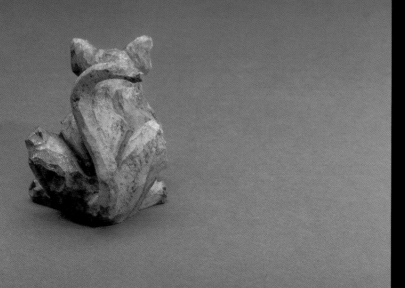

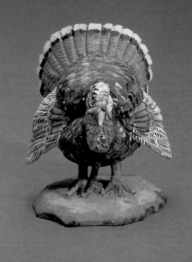

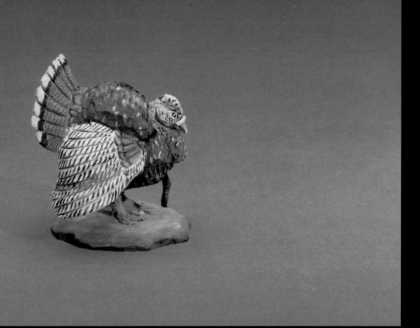

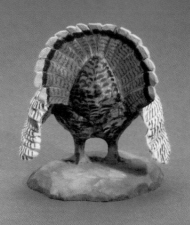

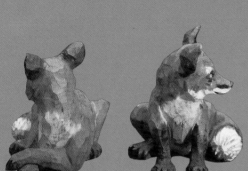
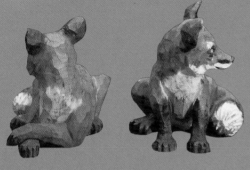

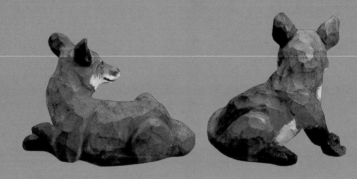

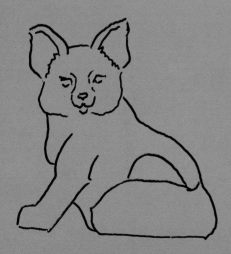

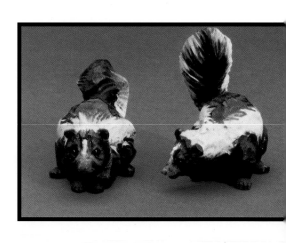

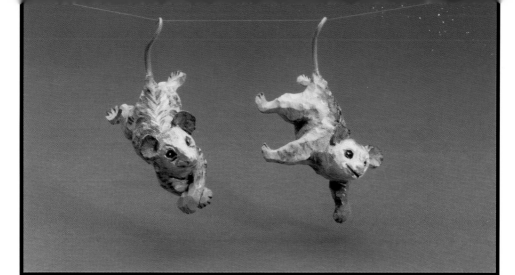

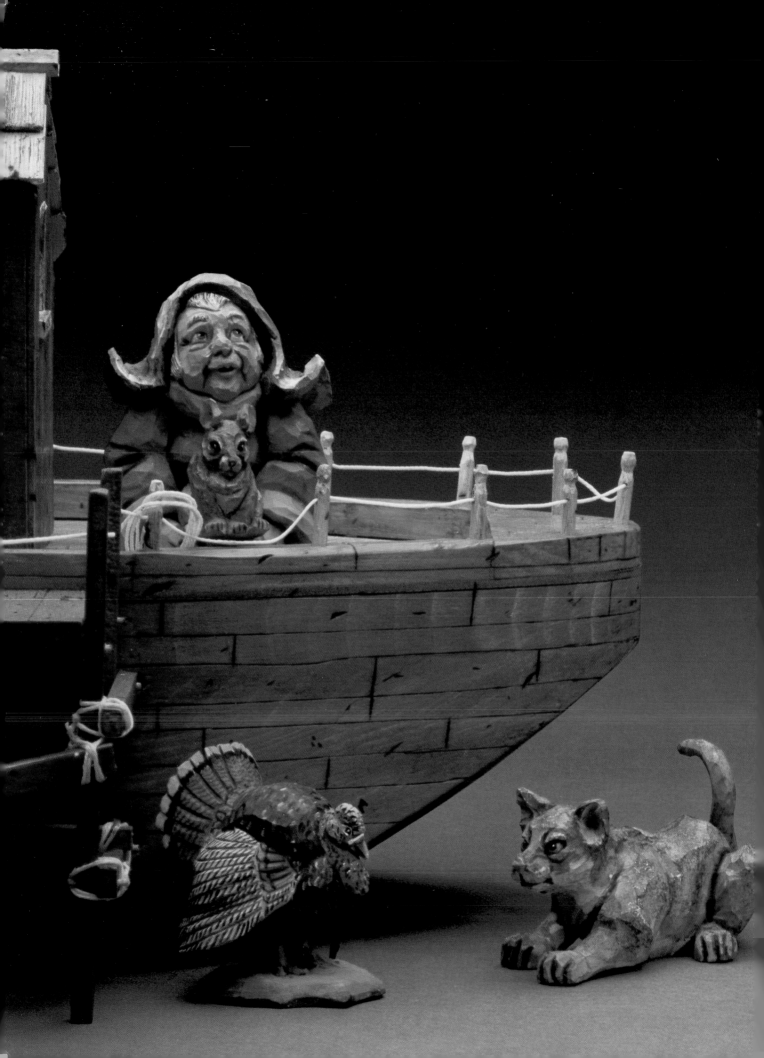